A Point of View

Ralph Steiner

A POINT OF VIEW

Wesleyan University Press

MIDDLETOWN, CONNECTICUT

Library of Congress Cataloging in Publication Data

Steiner, Ralph, 1899–
 A point of view.

 1. Steiner, Ralph, 1899– 2. Photographers —
United States — Biography. I. Title.
TR140.S683A34 770'.92'4 [B] 77-20513
ISBN 0-8195-5019-1

Distributed by Columbia University Press
136 South Broadway, Irvington, NY 10533

Manufactured in the United States of America
First printing, 1978; second printing, 1979

Without Caroline neither this book nor I would be.

Contents

Introduction

One of my first memories of Ralph Steiner, going back some forty-odd years, is that of a man bearing gifts. Wherever he went — to dinner, to a meeting with colleagues, a-courting — he always carried some thoughtfully chosen present. Whether it was an especially delicious pastry from the neighborhood bakery in Greenwich Village, an admired print, or a bag of exotic delicacies from the Armenian shops in lower Manhattan, he never came empty-handed. He has not changed; this book is full of gifts made by a skilled craftsman blessed with a way of seeing that brings joy to the viewer.

Ralph Steiner grew up photographically during the period when the artists using the medium were finding that they need not bend its qualities into imitations of etching, lithography, or painting. But while many of his contemporaries were still caught in the Pictorialist web, Steiner never stooped to sterile manipulation of his images. Instead his pictures glowed with the juxtaposition of rich blacks and luminous whites that a good photographer can coax from the latent silver image. Not that he was interested in the photograph for its own sake; on the contrary he was, and still is, only concerned with what the picture does, what it has to say. Whatever the message may be, however, it would be less clearly stated if Steiner were to be less meticulous in his use of photographic technique.

It was during the 1920s, formative years for Steiner, that modern photography began to be recognized as an art. In 1921 the Anderson Gallery in New York showed 145 Stieglitz photographs, and in 1924 the Royal Photographic Society gave Stieglitz its Progress Medal in recognition of his services to pictorial photography and particularly for his initiating and publishing *Camera Work*. The society's citation called this "the most artistic record of photography ever attempted." Indeed it was, but the manipulated soft-focus images it printed were too self-conscious for Steiner's taste.

The decade before the Great Depression also gave rise to such increasingly sophisticated periodicals as *Vanity Fair* and the *American Mercury*. H. L. Mencken, who edited the *Mercury* with a mordant sense of humor, took pleasure in debunking organized religion and exposing the often silly rituals of small-town service clubs. The *Mercury*'s familiar green cover, clutched in the hand of an undergraduate, signified a degree of intellectuality surpassed only by the possession of James Joyce's *Ulysses* with its blue cover.

Vanity Fair, in its own way, was even more a reflection of the time. The editorial content was certainly respectable but the photographs it presented were eloquent statements of how the talented, the rich, and the famous looked and dressed. Edward Steichen, Cecil Beaton, Baron de Meyer, Hoyningen-Huene were only a few of the photographers the magazine employed, and most of us eagerly thumbed its pages each month.

Stieglitz, with the formation of the Photo-Secession in 1902, declared photography to be an art form as significant as painting and sculpture. But now it was becoming clear that his statement was not just wishful. The issue of *Camera Work* devoted to Paul Strand had been a seminal event. Abandoning his usual practice of printing the reproductions by gravure on Japanese tissue, Stieglitz printed Strand's work on heavy stock more appropriate to the sharper, cleaner images. Along with Steiner, Strand, and Stieglitz, Edward Steichen and Clarence White in New York were presenting work with fresher viewpoints and less painterly concern. In the West, Edward Weston was becoming a major figure in the field.

This was the era of the speakeasy, the Charleston, *College Humor,* the flapper, and John Held, Jr. It was a time of shifting values and new viewpoints. For some, industrial expansion, with its promises of goods and gadgets for all, was a thing to be celebrated. The images of factories and skyscrapers presented in painting and photography by such artists as Charles Sheeler were seen as monumental structures, as beautiful in their own way as cathedrals. Weston's photographs of the Armco steel plant in 1922 were presented with the same detachment as the Mexican pyramids he was to photograph a few years later. Steiner saw the structures of the city, and

especially the signs and billboards, as wry comments on the foibles of people. His sense of humor refused to let him make just pretty pictures. He was laughing with those who had the wit to laugh at themselves. He could photograph the lighting fixtures on the top of a building silhouetted against the sky and make you think of some ridiculous parody of an insect, and he found sheer joy in the shadow of a rattan rocker on a sunlit porch.

Each of the photographers of the period had his own style, his own special way of seeing things. Stieglitz saw the buildings and the people of New York through mist and haze, or softened by snow, but always with distance between his camera and subject. In the early part of the century he had photographed a group of immigrants from a distance that made them seem picturesque. Now Paul Strand was literally poking his Graflex camera into their faces, and they were seen for what they were: human beings who fought against the poverty of their lives, often losing the battle.

By the time the twenties were half over, the motion picture had reached its thirtieth birthday. Steiner, Strand, and Sheeler all found in the new medium another way of expressing their photographic visions. Strand and Sheeler made a poetic celebration of skyscrapers and called it *Manhatta.* Steiner used his movie camera to abstract the forms that water takes and called it H_2O. Years later Steiner and Strand combined their talents to photograph the first important social documentary film, *The Plow That Broke the Plains.*

With the stockmarket crash and the subsequent depression at the close of the twenties, many photographers turned to making pictures with more social content than pictorial beauty. Steiner's work had never been divorced from the

society he belonged to, but now his comments on the excesses of a consumer-oriented economy seemed more prophetic than amusing. His work was now seen to have a depth of understanding that had sometimes been perceived as superficial amusement. His humor seemed more pointed than funny.

The thirties saw great changes in photography as the depression deepened. The Farm Security Administration photographers under the direction of the legendary Roy Stryker began to assemble a body of work that remains a great record of a country in pain. The perfection of the Leica camera made possible a new kind of journalism, photojournalism, and suddenly there were *Life* and *Look* and a whole panoply of new photographers. For some, the resulting plethora of pictures was unsatisfying. The very simplicity of the new cameras and the speed of the new photographic emulsions seemed to discourage taking time to think, and too much of the work in the picture magazines was either superficial or sensational.

Steiner and his colleagues in the East continued to work with large cameras. None of them considered the Leica a suitable instrument for serious work. On the West Coast a number of like-minded photographers including Edward Weston, Ansel Adams, and Imogen Cunningham formed a loose alliance for exhibiting their works together. They called themselves Group f 64 and their first exhibition at the de Young Memorial Museum in San Francisco in 1932 was a manifesto that fine photography lived in the West, too. Their work was characterized by sharp focus and great depth of field. Their skills and the brilliant light of northern California combined to produce some of the finest images ever made.

With increasing skill Steiner continued to photograph the things that caught his perceptive eye, while he earned his livelihood with ingenious pictures for advertising and public relations. Strand went to Mexico, where he filmed a motion picture called *The Wave* with all the sense of composition and attention to photographic values that he brought to his still photographs.

President Roosevelt's New Deal began to bring hope that the depression could be conquered. Some of the country's most talented young artists and intellectuals were supported by government projects and produced many lasting works of art. Pare Lorentz, a young motion picture critic, persuaded the government to let him do a report on the Dust Bowl and the exodus of its farmers. This "report" became one of the most significant nonfiction films ever made. It was called *The Plow That Broke the Plains,* and Steiner and Strand brought all of their great skills to shooting it. The result was strong social comment expressed with artistry and compassion, a work that set high standards for the documentary film.

The thirties were a time when much needed to be said. For Steiner and a few other photographers, the motion picture with its words and music seemed to be a medium capable of carrying content forcefully and economically, and so two years after *The Plow* was released Steiner and this writer pooled our skills with those of a number of other young people and made *The City,* a film that played in a special theatre at the first New York World's Fair for two years. Here was not only a subject that Steiner knew and loved, but one that allowed full scope for his particular kind of wit and humor. Full of visual jokes, but never made at the expense of people, it was the first film of its kind to bring delighted laughter from its audiences. And it still does. Almost forty years

later pictures of city dwellers catching a quick bite of lunch, pictures punctuated by machines popping out mountains of toast and pancakes, never fail to bring gasps of self-recognition and gales of laughter.

The thirties ended in war, and there was little time for laughter, let alone artistic pursuits. But later Steiner returned to expressing his love of nature, shown so eloquently in H_2O. His series of photographs of trees, clouds, water, and their details are loving gifts we can all share.

In the seventies photography has become a medium for artists, and photographs have become valued by collectors to a far greater extent than any of us imagined. Most of Steiner's great contemporaries — Stieglitz, Strand, Sheeler, Steichen, Weston — have left us, but Steiner still works at his craft, perfecting it and producing things of joy and affirmation of life.

WILLARD VAN DYKE

A Point of View

A Point of View

Background

I was born in Cleveland, Ohio, in 1899, before the world went wrong. By the time I was ready for long pants, a three-piece suit had gone up to $10.00 at Richmond Brothers store. As I write this, a single sheet of cardboard for mounting photographs costs $6.75 in the art store of Hanover, New Hampshire.

My father, an insurance agent, had told me that on both sides my family had come from a suburb of Prague, the name of which was *Nez da Sôv*. Only recently did I discover that *Nez da Sôv* is not the name of a place, but means "The Village of the Dolts" or, as the Germans would put it: *"Narrendorf."* What a place of origin!

In Cleveland we lived a ten-minute walk from the art museum, but I was never taken there by my parents — I think because of the nudes. However I saved up my dimes and bought a Premo camera before finishing high school. Although it had only three distance settings — far, middle, and near — it did have red bellows. The brilliant red leather may not seem important, but it was: it lent excitement and specialness to photography.

I suppose, as much as anything, I became a madman photographer to escape going into the brewing business of my uncle, my great uncle, and my second cousin. These were not three people, each with his own brewery, but one and the same person. Ours was a complicated family. In several ways it needed escaping from.

At Dartmouth College I met nature photographically in the form of New Hampshire. I had the idea that if I took some art courses they might influence my camera work. But back in those days anyone taking an art course except as an easy credit was suspected of homosexual leanings. "Modern Art I" began with Jan and Hubert van Eyck of the fifteenth century and ended with a trip to the nearby studio of Maxfield Parrish. But there was not one word about the Impressionists or other modern artists even though a nude had descended the stairs of the Armory Show in 1913 — eight years before. Dartmouth in those days was rather far north. Today the world has swung around so that a Maxfield Parrish may hang in a student's room again, but now as an example of high camp.

I imagine I was the only student in "modern" art who was interested, but I managed only a

passing D while football players, stuffed with the final examination questions of the past ten years, got A's.

"Doc" Griggs, a popular outdoors man and professor of biology and photographer of animals, suggested to me that the college might be induced to let him start a class in photography, although New England colleges had the general idea that education should hurt in order to be instructive. Perhaps the college allowed him to give this class because he was the only faculty member who walked around town with a tame crow on his shoulder. I was the only member of the class. It was held once a week in the evening at his home. There he served me the enormous strawberry shortcakes he was famous for making. It was not a painful course since he'd say to me: "You know more about it than I do, show me what you've been doing."

I have always harbored the thought that my mania for photographing lowered my classroom grades so that I almost didn't graduate. But I recently came upon my college record, and found myself exactly in the middle of my class statistically. We were all a lot less bright than college students today or marking is now a lot more generous.

Still, at Dartmouth, I covered myself with glory as a private in the army of World War I by being one of the two soldier-students (the other was a drunk) in fifteen hundred who failed to get credit for military training. I hated every second in the army. I hated being ordered to do things. I never did understand why stripes on a man's arm should turn him into a snarling dog, barking his orders. I'd have cooperated far more willingly had orders been phrased: "Please. About face. Thank you." And I never did manage the properly ferocious "GRRRRR!" when bayoneting the straw dummy. I wish I could claim credit as a pacifist for my failure as a soldier, but I was neither that bright nor that humane. I was merely inept and self-willed.

I kept taking pictures of the college and the countryside, but much of what I did was the proper, pictorial photography "shoulds" and had little relation to what I thought or felt. The summer after graduation I published a book of photographs of the college. A few of the pictures caught a bit of life, but many were arty beyond belief. I had no idea then what was my material — what to photograph — nor why a photographer photographed; but worse, I did not know that a photographer is required to ask such questions of himself.

Photography School — Home of Design

After college I spent a year (1921–1922) at the Clarence White School of Photography. It was certainly not the profit-oriented chamber of horrors most photography schools then were or now are. Clarence White, one of the early American photographic "greats," was a kindly man who mostly left us to our own devices except for a weekly and most charitable criticism session. His idea of a photographic education was that we were to do one of everything: one portrait, one still life, one platinum print, one gum print, etc.

Clarence White had been bitten early by the bug of Japanese design, which had so attracted and influenced Degas, Manet, Cassatt, and Toulouse-Lautrec. In the issue of *Camera Work* devoted to White's work there is a photograph of the small Ohio town where White started. It

contains no iota of information about or feeling for a small town at the turn of the century. It is pure art-design, soft and highly Japanese. It says much about a point in American photographic history, but nothing about Ohio or about White's feeling about his town.

White hired a design instructor from Teacher's College of Columbia to dose us regularly with design: lectures, design problems, illustrations of design in art. Of course the organization of lines and spaces in a photograph has

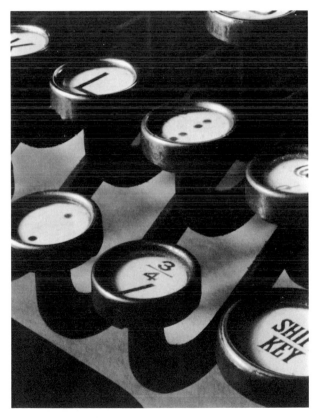

One of my 1921 White School exercises in design.

importance, but what we were taught was an approach to design which was suited to the painting of the time rather than to photography. We were taught rigid rules and formulae for what was "good" and what was "bad" composition. Besides being absurd, such an approach is impractical. First, a photographer cannot move a tree in a landscape to satisfy a painterly demand for a Steelyard Balance composition. The photographer has to accept the world's arrangements as they come — unless he is a master cutter-outer and paster-upper like Rejlander. Second, design or composition is a highly personal matter. Statements that horizontal lines are static and peaceful, vertical lines give a sense of movement, while diagonal lines equal violent action — these are things a student writes on an examination paper, not aids to composing. Only a Prussian photographer might set up his camera, saying: "Now I make violence by use of diagonals."

Interestingly, Degas and Ben Shahn reversed the influence of painting composition on photography. Degas, an amateur photographer, and Ben Shahn, a part-time photographer, were influenced by the look of the world on a camera's ground glass, and constructed some of their paintings in a most unpainterly manner. Degas would shove the focus of his painting far to one side, and Shahn would slice a man in half as he showed him emerging from the side of a building.

Today there are photographers who completely (and satisfyingly) ignore classic design. It isn't that they defy what has gone before — they pay no attention to it. Some photographers, Eliot Porter for one, think nothing wrong in making an all-over photographic pattern of grasses or flowers — all the elements evenly spaced — no such thing as a center of interest. Photographers

today picture the world our eyes see rather than worked-out, traditional arrangements. The departure from painterly design has gone so far that there are now photographers who shoot from the hip — never sighting the camera with their finder, and accepting whatever accident results.

On the other hand, some photographers have a gift for instant organization. Cartier-Bresson is a master at this. Unlike the painter who spends days or weeks mulling over his choice of compositional sketches for a painting, Bresson makes up his mind in a hundredth of a second; if he doesn't, his subject will have left the picture area. Somehow, magically, this man manages to compose disturbing subjects disturbingly and bovine subjects bovinely.

What resulted from the White School emphasis on design was that for years I went around with eyes like twin vacuum cleaners sucking up designs wherever they poked their heads up. On the very first day at the White School, as the students waited in the assembly room for Mr. White to appear, a Japanese student by the name of Waida sensed that I was Jewish. He whispered to me: "Stahnah, you and I should be best photographers in this class; we are the only Orientals here." I guess he equated Oriental with design and equated design with "good." Thank God, my Orientalism was only Middle Eastern, and I finally escaped the necessity to straightjacket the things of this world into standard compositions.

Stieglitz and His Affirmation

Alfred Stieglitz came once to lecture to us. The students were all — myself included — Yahoos. We had absolutely no idea what Stieglitz was talking about with his insistence that a photograph had to be an "affirmation." Stieglitz disdained to explain that word, and the White School had no dictionary. I think most students dismissed him as some kind of weird character — full of drama, but making no sense. But I had a small idea that "affirmation" might contain more usefulness than whether a Zeiss or Goerz lens should be used. After his talk I alone went up to him to ask if I might come to see him, but I remember his answer clearly: "I am not interested in helping individuals." I was disappointed because I felt I did not know, and was not learning at the school, the great, secret answer to photographic creativity: at what to point my camera and what attitude to express toward the things in front of my lens. I felt that, if pursued, this man might reveal to me THE FORMULA for transforming the lead of my confusion into the gold of creativity.

Eventually I discovered for myself the utterly simple prescription for creativity: be intensely yourself. Don't try to be outstanding; don't try to be a success; don't try to do pictures for others to look at — just please yourself. My father used to say: *"Erst komm ich; dann komm ich noch wieder; dann komm ich noch einmal wieder."* When the registrar of the Paris Conservatoire asked Debussy what rules he followed, Debussy's answer was: *"Mon plaisir."* E. E. Cummings put it: "To be yourself and nobody but yourself in a world which is trying night and day to make you everybody but yourself is to fight the hardest battle there is and never stop fighting."

As I've said, for a while in the twenties there was a fashion for making photographs look as much as possible like nineteenth-century paintings. Stieglitz himself, in the early days of *Camera Work,* fell into this trap, but later he was in the forefront to establish photography as a

medium with its own values. He also put to rest the debilitating question that was so often debated: "Is photography art?" by making the most terse and apt statement of his life. He said: "I like some photographs more than most paintings and some paintings more than most photographs."

Stieglitz and Exclusivity

An amusing (after it was all over) and most revealing story was told me by Ansel Adams of his first visit to Stieglitz to show him his work. Adams had brought Stieglitz a letter of introduction from a wealthy West Coast woman. Stieglitz read the letter and said that he supposed Adams expected approval of his work because he'd brought a letter from a wealthy acquaintance. He told Adams to put his portfolio on a table and to go sit down. He motioned in the direction Adams was to sit, but there was no chair — only a radiator with deep ridges on top. So Adams sat on its corrugations while Stieglitz undid the straps of the portfolio. Slowly he looked at each photograph. Then he put the pile of pictures back in the portfolio, strapped it, handed it to Adams. Stieglitz said not one word, nor did Adams as he walked to the door. Just as Adams was about to close the door on himself, Stieglitz called him back. Again Adams was told to deposit the portfolio on the table and told to sit on the radiator, and the same slow operation of looking at pictures was gone through. Adams, no ninety-pounder, had the feeling that his bottom would be permanently corrugated by the radiator, but he sat. Finally Stieglitz told Adams: "These are some of the most beautiful photographs I have ever seen," and gave him a show.

A short time ago I heard Stieglitz referred to as "the Clubman" for his exclusivity. His inclusion of certain members in the "club" and his blackballing of such photographers as Weston and Evans suggests a need to preserve a private kingdom. Weston, out in California, often on the edge of not eating, could have used a show given him by Stieglitz in New York. When Walker Evans showed Stieglitz his work, the only comment was: "Keep working, young man."

I have always been fascinated by the P. T. Barnums, the Wizards of Oz, the Lord Duveens, and the Stieglitzes — all standing tall on their self-erected pedestals. If only Stieglitz had let his work speak for him! But whenever he talked he played Moses bringing the tablets down the mountain. If only he had learned the saying of Lao Tse: "On him who would glitter the sun never shines."

Stieglitz was by nature one of history's greatest salesmen. He would demand proof from a potential buyer of his worthiness to own a painting or a Stieglitz photograph. He would ask if an *Equivalent* (one of the cloud sequence), which he said represented a lifetime of his feeling, was worth as much as the would-be purchaser's Cadillac or a year's rent on his Park Avenue apartment. He would batter a would-be purchaser until the poor man was almost on his knees, begging to be allowed to buy a print. The beaten victim would try to prove his worthiness and sensitivity by the size of his check, and so the selling price was a splendid one. However, it should be added that it is said that when Stieglitz sold the work of one of his artists he took no commission on the sale.

I was once invited to dinner in Stieglitz's apartment on top of a hotel on Lexington Avenue. Georgia O'Keeffe, his wife, talked to me right through Stieglitz's nonstop insistence that the world would not be able to get along without

him when he had gone. I tried to pay attention to O'Keeffe and her questions on my left without being discourteous to Stieglitz on my right — unsuccessfully — and wished desperately I were any place but at their table.

Today's image of Stieglitz rightly stresses the fire within him, bigger than himself. But the idea of Stieglitz as a sage and a source of wisdom is hardly valid. He was a feeler, not a thinker, and his manner of talking and writing was so tainted with ego that the listener was divided between sadness and irritation.

We are fortunate today that in his own work — in later years — he moved away from the romantic grandiosity of "The Hand of Man" and "The City of Opportunity" toward Blake's vision: "To see the world in a grain of sand, and Heaven in a wildflower" — his concept of Equivalents.

My First Job

I never did receive my graduation piece of paper from the White School because Mr. White had before graduation got me a job making photogravure plates at the plant that had made the plates and printed all of Stieglitz's American-made *Camera Work*. That magazine had expired before my entrance on the New York scene, and I made plates mostly for honorific banquet menus. But I did make the plates for gorgeous portfolios of Eskimo pictures by a jolly, wonderful Irishman called Robert Flaherty. It seems he'd been up near the North Pole making a film about a man called Nanook.

Since the etching process was not scientifically controllable, the plates had to be laboriously retouched with etching tools. The retoucher was a lovely old philosophical anarchist.

From the pictures in the Hearst papers I'd thought of anarchists as hairy, bomb-throwing wild men. Mr. Gravichec, the retoucher, was as far from bomb-throwing as one could be. I knew him as a gentle lamb. At lunch he used to expound his political theory to me. He told me that the causes of crime were jails and policemen; abolish these and there would be no crime. I did not understand then (nor do I now) but the idea seems suited mostly for the saints. Mr. Gravichec was old; death was not far from him. When the dark days of autumn came he said touchingly: "It gets late early now."

First Steps in Commercial Photography

In 1923 I quit my job at the photogravure plant and gradually drifted unthinkingly and effortlessly into advertising and magazine photography. In those days there were practically no "artistic" or "creative" advertising photographers, so there was little or no competition. The *Woman's Home Companion* gave me one of my first jobs. It was to photograph a piece of Javanese batik. The batik cost fifteen dollars. I didn't know how much to ask for photographing it. When the art director suggested twenty-five dollars, I was bowled over to discover that a photograph of a thing could be "worth" more than the thing itself. Nowadays I sometimes ask photographers: "Which is worth more — an apple or a photograph of an apple?" After all, the apple has taste, smell, nutrition, three dimensions, life, while a photograph is flat, inedible, etc. Naturally, the answer is that if the photographer has included a bit of himself in the photograph, then the photograph outweighs the apple itself, since a man outweighs an apple.

Art directors were impressed by the great depth of sharpness of my photographs. This extra sharpness resulted from the fact that I could not afford proper lenses and shutters. I bought spectacle lenses of different focal lengths for about a dollar each, and built them into paper tubes as lens mounts. A home-made paper lens cap substituted for a shutter. A lens cap couldn't be taken off and replaced in less than half a second, which was too much exposure outdoors on a sunny day. So to cut down the light I made tiny holes in black paper as lens diaphragms. Such small openings made everything sharp from near to far. A decade later on the West Coast there came into existence the $f/64$ school of photography. My poverty made me the sole member of the East Coast $f/180$ school.

Political Orthodoxy Be Damned

About this time I was asked to teach a class in photography at a Communist-dominated photo league. At the end of the second lesson I was fired from the job. This is what I had done: at the first lesson I asked the students to leave their cameras at home but to take paper and pencil to record what they saw in the seventies and eighties on fashionable Park Avenue. Then they were to do the same on Park Avenue near Harlem underneath the New York Central Railroad elevated tracks. There, for block after block, pushcarts with food and clothing were lined up. There the poor did their buying. At the second session of my class one student after another read almost identical notes: "Along expensive Park Avenue live the capitalist rich in unearned luxury and elegance. Under the railroad the downtrodden victims of the rich live in misery."

"Yes, but what did you SEE?" I asked. So I read them what I had seen and taken down on paper. The monotonous rows of expensive apartment houses seemed a city of the dead. The windows of the rich looked out, front and back, on dull facades and unimaginative architecture. Visually and functionally it was what architects were calling "a high-class slum." The sidewalks were almost deserted. Every so often a taxi would draw up, and a woman would scurry into the black hole of the doorway. Once in a while a small boy in his St. Botolph's private school uniform would be herded home by his nanny. But uptown, under the railroad, life bubbled. Children chased each other under pushcarts. Mothers screamed at them and went on bargaining for merchandise. Two boys with sticks and garbage-can covers dueled like knights of old. I was finished — fired — kaput because I could not see the two Park Avenues through a thick volume of *Das Kapital*.

A Great Photographer-To-Be

About this time I met a beautiful, angelic-looking, very young man who had come from France to the United States with the hope of discovering whether he should make films or still photographs. There was not one Leica camera on his person. I had a talk with him about film making versus still-photograph making. He was a serious listener and questioner. When we finished talking he said most solemnly that whichever he did, it would be special and superb work. In all my life I have never heard anyone say a thing like that about himself without seeming immodest. But his simple, unaggressive seriousness impressed — even awed — me. He was Henri Cartier-Bresson.

Paul Strand Makes Me Feel
Not a Photographer

One day in 1926 or 1927 I met the great photographer Paul Strand. He invited me to his house to see some of his photographs and to a dessert of cheese on rock-hard Bent's Water Crackers. Strand stunned me by showing me his Mexican prints. I was pole-axed; I had never seen prints so rich — with such real texture — and so glorious in tonal values. He took photography with proper seriousness, and so left each print up for my viewing for what seemed five minutes. I was embarrassed by not being able to respond adequately to the long viewing. At that time I was verbally limited — my critical judgment consisted of two values: good and bad, for which I possessed two acutely definitive words: "swell" and "lousy." I tried to fill in the print viewing with appreciative utterances such as: "Gosh!" "Gee!" and "Wow!" I realized that by contrast I was not yet a craftsman, and was inspired by the excellence of Strand's work to do an extensive something about my technique.

Strand, the Noncompromiser

The Strand I got to know was just about the most grimly serious person I'd met in my life. He was a walking Sword of Rectitude. For him there was something called Right and something called Wrong, and especially in photography they were poles apart. Like Alfred Stieglitz, he had no difficulty using that awesome word "truth." For Strand, truth was an absolute, like the world's standard meter: a platinum bar, kept in a vault in Paris at constant temperature and accurate in length to thousandths of a millimeter. I see truth as the sum of each person's background, lifestyle, and prejudices. Philosophers have a saying that "the only thing constant is change." I'd think it equally true that what is most inconstant in the world is truth.

Merely because a photograph is made by a machine brings it no closer to truth than a painting made by a man's hand. What is on the face of a photographic print is a compound of the thing photographed plus an X-ray of the photographer's heart and mind. When Strand photographed New Englanders, Scotch Hebrideans, Mexicans, he compounded his granitic character and their starkness with magnificent results. But that result, while a truth, was Strand's truth, not THE truth. When Strand photographed Italians and Frenchmen, his temperament and the Latin were at odds. His Latins are stolid, immobile, and do not relate to one another. When I am in Italy I can hardly eat my meals, I am so taken with watching the hyperexpressive use of Italian hands. One Italian may be telling another about the high cost of plumbing, but his waving hands recall Stokowski conducting Bach. Strand's Italians and Frenchmen are not my Latins. What happens to truth in this case? Because of my uncertainty, it is not a word I use. I follow the dictum of Oliver Cromwell: "Gentlemen, I beseech you, in the bowels of Christ, think it possible you might be mistaken." I find I often am.

Here are two examples of the superserious, unsparing quality of Strand. One story was told me by Ansel Adams. He had flown from San Francisco to do a piece of work for New York's Museum of Modern Art. He was busily doing that work when an urgent phone call came from

Strand. Was Ansel busy; could he come to Strand's apartment for an emergency consultation? Ansel allowed that he was busy, but an emergency. . . . So Ansel dropped his work and took a taxi to Strand's. He knocked, and, at Strand's invitation, came in. Strand was bending over a work table on which lay a sheet of mounting board and a small print. Strand shifted the print upward on the mount a half inch and then downward, and said: "Does it look better up here or down there?"

Paul Caponigro once told me that as he was showing his photographs to Strand, he was admonished that certain of his dark tones contained no detail or texture. To tell that to a first-year student is one thing, but to tell that to Caponigro would be like telling Einstein that one plus one is two. Caponigro wanted darks without detail, and he had a right to print as he wished, but to Strand there was right and there was wrong. In telling me this, Caponigro said: "I take responsibility for the tone values in my work." Strand is reported to have objected to the detailless blacks in Stieglitz's photographs of New York buildings. Three men; three truths.

At one period in Strand's life he used a bulky, awkward monster of a 5 x 7 inch Graflex camera. I too owned one. Neither Strand nor I was in love with the 5 x 7 proportion. To our minds 5 x 6¼ was more in keeping with Greek relationships. Both Strand and I blocked off the ¾-inch unwanted short edge on the ground glass. My negative would give me a full 5 x 7 print, and I would trim off the unwanted slice. But not Strand. He took his camera to a mechanic; there a black metal bar was bolted into the camera to block off the unwanted image from the film. I had the opportunity to change my mind at the last minute about what and how much to eliminate by trimming my print. Strand wanted the stern imposition of a rigid bar to prevent such later choice.

Every man is of one piece, and has the limitations of his virtues. Strand's work had, on a grand scale, the virtues of his limitations. And, for me, when Strand photographed material that related to his character, he — not Stieglitz — stood on the peak of Olympus along with Weston.

Working to Earn the Right to Call Myself a Photographer

Having seen Strand's work, I realized that I was not yet a photographer. The path to that end was not clear to me, but I knew I had to learn my technique well enough to make wood look like wood and stone look like stone. I knew it would take a concentrated piece of time to even make a start. With luck I got invited to spend the whole next summer at Yaddo in Saratoga Springs.

There one can work at writing, composing, or photographing without interruption all day and night. The Yaddo Foundation built me a darkroom in the stables, fed and bedded me for three months. I spent all my days photographing objects with textures and a good part of the nights developing my 8 x 10 negatives. That summer I made the series of Ford car pictures and the NEHI signs. Late one day I saw the sun, about to go down over the horizon, casting the shadow of a chair on a porch wall. No one in the world's history ever set up a huge, cumbersone 8 x 10 camera and snapped the shutter as fast as I did. Ten seconds later the shadow was gone from the wall. Somehow that rocking chair picture,

labeled by someone at the Museum of Modern Art "American Rural Baroque," has been reproduced so often that many people think it the only picture I've ever made.

Education through Clurman and the Group Theatre

The Stanislavsky-oriented Group Theatre happened to lay its foundations in my studio. Harold Clurman would talk about an ideal theatre from midnight to dawn on Friday nights, while a group of actors listened on the chairs I'd rented from an undertaker. From that year of Clurman's talks, and later from the fascinating exercises of the Group, I began to get the education I had doltishly escaped at Dartmouth. I began to read, to look at art, and to think about what I read and saw. Except for my eyes and a bit of energy, I think I was pretty much wet blotting paper before Clurman and the Group came into my life. I owe them thanks.

Early Film Making

Ever since the late twenties I have made short films. At first I used my earnings to pay for the film — 35 mm film was cheaper in those days than 16 mm is today. Then through Edith J. R. Isaacs, the editor of *Theatre Arts Monthly,* I received a grant from the Elmhurst Foundation. The first film I worked on I threw away in midstream — nothing moved. My next film, *H_2O,* I am told by film historians, was the second earliest American "art" film — the first being *Manhatta* by Paul Strand and Charles Sheeler. Since my first, abortive film showed immovable objects, I picked water in motion for my second.

I knew nothing about film editing — few film makers outside of Hollywood did — but I induced Aaron Copland to help me edit. He claimed he knew nothing about film, but I persuaded him that a composer should know about unity and progression, and that these had to be important to film editing. Not long ago I saw that film for the first time in almost forty years, and I thought that Aaron and I did not do too well in organization. I saw that Aaron, in choosing a career of composing rather than film editing, showed splendid judgment. But the film won a first prize of five hundred dollars in a *Photoplay Magazine* contest and sent the blood rushing to my head.

Perhaps too much blood went to the head, for my next film, *Mechanical Principles,* was from start to finish, in all departments, a plain mess. *Mechanical Principles* and the youth who made it make me think of a story about the great piano teacher Leopold Godowsky. A supposedly talented young pianist was brought by his father to play for Godowsky. After playing, the youth was sent from the room so the father could question the great teacher. To: "What do you think of his playing?" the dour Godowsky replied: "About genius you can't tell, but talent he hasn't got."

My big film moment on Broadway came when the Copland-Sessions Concerts commissioned Colin McPhee and Marc Blitzstein to write music for three of my short films. The music was not recorded, but was to be played by a sizable orchestra in synchronization with the films. I knew almost nothing about splicing films, so they kept breaking during the performance. The projectionist would hurry to rethread the projector while the poor orchestra leader went mad slowing the orchestra down to get back into syn-

chronization. When one film happened to end with the end of the music a loud cheer of relief went up from the whole audience.

Except for some innovative photography these films now seem primitive and inept. At the same performance Man Ray's *Emak Bakia* was shown. It was dada and funny. Man Ray's relatives came down from the Bronx hoping to see a shower of gold in their relative's future. But none of the very few experimental film makers of the day made a nickel. Our films sat in the dark of tin containers — their only use being to test the archival quality of Kodak film stock.

George Grosz and Pie in the Sky

About this time I made a semidramatic film, *Cafe Universal,* with members of the Group Theatre. It was an antiwar film, based on post–World War I drawings of George Grosz. The direction and acting were not realistic, but more like posters come to life. My chief actors were Elia Kazan and Art Smith, while Clurman, Robert Lewis, Paula Strasberg, Morris Carnovsky, Clifford Odets, and other actors played minor roles. Unfortunately this film was lost in my later move to Hollywood.

I also made a film, with Elia Kazan in the lead, on a New York City dump. The thrown-away things of the dump furnished rich props and costumes, and presented us with ideas for sequences. The film's idea was the hobo song: "You'll Get Pie in the Sky When You Die." Neither this film nor *Cafe Universal* was made from a written script. Rather, the action and the direction evolved out of general ideas, out of the physical background, and from improvisation. The "Pie" film had many comic improvised sequences. I remember that a visiting commissar of

the Soviet film industry viewed the film and reproved me for my lack of seriousness and my failure to have the proper attitude toward the lumpen proletariat. I showed a program of my early films also to Martha Graham and her group of dancers. She approved highly of my "art" films, but said that "Pie" was to her the certification of the death of an artist (me). Maybe so, but maybe Graham was constructed with a weak funny bone.

The Plow That Broke the Plains

One happy result of the Copland-Sessions concert was that Parc Lorentz, a film critic, attended. He was about to embark on a film about the dust storms for the government. He hired me as cameraman. I suggested that two men with cameras would be necessary, and recommended Paul Strand as the other cameraman, plus Leo Hurwitz to assist. Since Lorentz was out in the field with us for only a very short part of the film making, I think I can say that Strand and I were "director-cameramen." In documentary filming, where events or the look of things cannot be directed in the sense that actors are directed, it is the person with the camera who, through his aesthetics and technical skill, shades meanings and conveys the feeling of the scenes.

I learned a lot from Strand while filming the vast, open, almost featureless vistas of Wyoming grass. He made compositions out of the darks and lights of the valleys and hillocks. Strand had a biggish Akeley camera, which he had to hand-crank as in the days of David Wark Griffith. I had a compact British camera with a powerful spring motor drive and could run around fast to collect many of the medium and close-up shots. We ran out of film on the Texas Panhandle and

could not work. Appeals to Washington were unavailing. Strand spent days constructing the longest, most Rabelaisian, highly unprintable punning description of the government agency that had abandoned us. Even in this age of freedom to use vulgarity, his punning was too strong to pass through the mails. A mild example was that he always pronounced signs forbidding entrance as "No-trees-pissing." His punning definition of Horehound Drops (a sort of cough drop) was: "Bad lady dog drops for Detroit." I mention Strand's puns because they stood out so unexpectedly from his normal ponderously solemn manner.

During the period when we had no film, Hurwitz, perhaps feeling that he had too little function in the film, decided to rewrite Lorentz's script with the help of Strand. I kept out of the rewriting project. It may just be that I had sense enough to know that producer-writer Lorentz would not wax enthusiastic over the rewriting of his script by his employees. Anyway, since the new script was to differ politically with Lorentz, and since I was (and still am) hardly a political animal, I rented a twenty-two rifle to shoot tin cans while the others rented a typewriter.

When Lorentz finally arrived with raw film stock, he went into a rage about the "bettered" script. Imagine Beethoven discovering that a small-town bandmaster had added another note to the awesome beginning four of his Fifth Symphony. Lorentz sent the two men away with a list of various shots he wanted made. I stayed with Lorentz to complete the film. I was fascinated by him. He was truly a genius, and like many geniuses, he was flawed. When anything went wrong (a farmer didn't show up for a four A.M. appointment, or Washington bureaucracy complicated things) he saw the Fates drawn up against him. But he was a genius at pulling a visual and unifying concept out of a mass of economic, political, and sociological facts. And he was a master at writing commentary, editing film, and working with a composer.

Some years later when Willard Van Dyke and I were trying to boil down a hundred pounds of diverse lectures and books on city planning into a workable outline for a film, *The City,* I finally went to Lorentz's house and hovered over him to extract (yes, like a dentist) from him three clear, simple, orderly pages of outline. It was a revelation: light out of darkness.

The City

The City was the biggest film I ever worked on. I got together with Willard Van Dyke, a West Coast still photographer and film maker, and we filmed and directed it. Another West Coast friend, Henwar Rodakiewicz, came east to edit and plan — a most important part of the end result. Music was composed by Aaron Copland. Van Dyke chose to film the rural and more lyrical sequences. That was fine with me, since I think it suited my nature more to work on the more abrasive material: the horror of filthy Pittsburgh and its surrounding iron towns, and the wry humor of nervous crowding in the metropolis.

We worked for a client, a committee of some dozen architects and city planners. They differed among themselves considerably in their approach and conclusions about city planning, so we just went ahead and did it our way. When, at intervals during the filming, the committee wanted to see what we were doing, the editors would scramble together a mess of unrelated shots for viewing. We didn't want to be unhorsed

by contradictory directives. When the film was completed after nine months of work, the committee viewed the end product with considerable dismay: "You have treated a serious subject humorously" and "You have wasted $50,000." One architect looked as if he were about to explode. Red with rage, he had to be helped into a taxi to go home. But when the reviews came out with high praise — especially for the humor — we heard that one of the complaining clients had said: "I told them to put in a bit of humor."

Some thirty years after the making of *The City,* Willard Van Dyke and I were talking to a film group about the making of the picture. I made a joke of the fact that Willard and I were so idealistically simple-minded in those days. I told how, near the completion of the film, the money had run out, and we both dug into our minute savings accounts to finish it. As I remember, we each got the huge sum of seventy-five dollars a week for the nine months of the film's making. We couldn't have squirreled away too many nuts out of such salaries. The point I was making was that it never occurred to our innocent minds to ask the Carnegie Foundation or the sponsors (some were millionaires) for the completion money. Willard spoke up to say that it was not foolish of us — that the film was our beloved child — that the more such idealistic innocence on the part of film makers, the better. He was right. I was wrong.

The Sun Shines. The Sun Dims

The film ran for a year at the New York World's Fair. *Life* magazine and the *New York Times* gave it several pages and heaped praises on Willard Van Dyke and me. *Time* said we had made a million-dollar film for fifty thousand dollars. Best of all, the newspapers were unanimous in saying that the film was entertaining. One critic, obviously not a World's Fair enthusiast, recommended a trip to the Fair if only to see our film. Willard and I were famous for about half a day. We thought we were well launched as film makers and could earn a living thereby. We wrote and submitted scripts to various organizations that seemed to want a film made. One huge Midwest chemical company wanted a film about the importance of phosphorus in diet to make good bone structure. Our script detailed shots showing American families living on insufficient diets. When we went out to confer with the top executives, one of them objected, saying that to depict undernourished Americans was unpatriotic. Another executive helpfully offered: "You could show undernourished Mexicans; no one cares about them." We did not make that film.

To eat, we finally took on the job of making a film for the Mutual Savings Banks Association of Massachusetts. An idiot advertising copywriter had thought his script an easy entrance to Hollywood. It was a series of much too obvious pats on the backs of mutual banks and the virtues of saving. It was a horror — a disjointed mélange with no cohesion — the shots held together by film cement only. Both Van Dyke and I learned from this film that the client is all too often wrong — even to the extent of not knowing what the film should say about his company or his product. Years later I telephoned Willard to say that I had a few minutes before told a client to go to hell. Willard told me that he had hardly ever made a film without offering to resign during the process, despite the fact that he usually worked for foundations rather than for commerical enterprises.

Willard Van Dyke

Willard Van Dyke is a man of sentiment. That word has come to connote softness, but its real meaning has to do with "elevated feeling and tenderness." God knows this world stands in need of any available tenderness. Willard's film *Edward Weston and California* is in my eyes closest to him, and also just about the best antidote for negation of life. It is natural that it should be so, since the seacoast and mountains of California were the meat and drink of his youth, while Weston, a spiritual father to him, led him in the way of "life enhancement."

As I write, Willard has just selected and hung a show of Weston's work at the Museum of Modern Art in New York. Willard had gone on to be for many years the head of the Museum of Modern Art's Film Department, where he became father-confessor to countless young film makers of our time. I am warmed by the remembrance of a scene after a museum film showing. A group of young film makers was sitting at a table in the Members' Lounge having refreshments while Willard, chairless, was down on his hunkers talking vivaciously to them. There was no thought in him of his prestigious position in the film world. He had something to say to young people, and he was saying it. No ego problems.

The last thing I see at night and the first thing in the morning is a gift from Willard — a print of Weston's artichoke. It is not so much a sliced artichoke as the wings of the angel who announces the dawn. It's a nice way to be reminded of Willard.

The Lesser of Two Earning-a-Living Evils

To return to the question of earning a living from film making, there were at that time few opportunities to make social documentary films, and making films for advertising seemed even more horrible and less secure than making still photographs for advertising. My choice was simply the lesser of two evils.

Walker Evans earned his living by working as a writer and photographer for *Fortune* and later as a teacher of photography in Yale's art school. Yet he belabored Steichen as despicable for making photographs for *Vanity Fair, Vogue,* and advertising agencies. I would suggest that a man is best used when he does what there is in him to do, and that Steichen made a contribution while enjoying the process enormously. There never was a better craftsman, and Steichen, always the charmer with a smile that could melt tool steel, charmed and photographed the newsworthy people of his day characterfully and entertainingly. I think of him as just about the only commercial photographer who made money without letting the process rasp his nervous system.

Many young photographers brought their work to Steichen and asked him how to use their cameras for earning a living. Steichen would tell them to wrap packages at Macy's in order to eat, and to photograph in their spare time. He may have realized that what worked for him, and made him happy, might destroy the talent of others.

Some photographers earn their living by teaching photography. This too has its dangers. Thornton Wilder, playwright and author, used to advise aspiring young writers to earn their liv-

ing by teaching, but not by teaching English since it would conflict with their writing.

Paul Strand is quite properly looked up to for devoting his entire life to "pure" photography. But then he was lucky in that his fairly well-to-do father sympathized with his photography and supported him. Strand was not against earning money with his camera, but would do so only on his own terms. He was once asked to photograph a glass of fizzy bottled water for a manufacturer, and was asked his price. Paul told the advertising man that he would charge one hundred dollars. This was back in the 1920s, when a hundred dollars equaled five hundred today. That was agreed upon, and then Paul said that the hundred dollars would be for each negative exposed. The advertiser assumed that several negatives might be exposed until he himself was happy with the result. But Paul put him straight: the photographing would be open-ended — negatives would be exposed until Paul was happy with the result. Quite naturally, the fizz water was never photographed.

I recall that in those early days Paul was rock-rigid about letting his work be reproduced. He once announced to me that he'd never let his work be reproduced until the engraving industry's standards reached the level he set for his own photographic printing.

Ulcers and Heart Attacks

I knew some of the most successful commercial photographers of my day. The fashion photographers were the unhappiest. After all, they had the job of making each month's fashion photographs look different from last month's — always something fresh and new — a difficult thing and stressful, considering that the models have each only one torso, two arms, two legs, never a bosom. With such limited material how does a photographer "create" something original each month?

I knew the "gal Friday" of one of the topmost photographers of that day. She told me that even though his income was in six figures, he worried if no new assignment came in for two days in a row. He would fret that he was finished — that his clients were bored with his work. Of course, he finally had to get out of the business. He did — he dropped dead of a heart attack while still young.

Many of the six-figure advertising photographers led fragmented lives. It may have been apocryphal, but I heard of one who kept trading in one low-mileage Jaguar for another newer one, and also kept trading in one low-mileage, ninety-pound fashion-model wife for a newer model. This sort of thing can be, to quote Thomas Carlyle, "a monument to a misspent life."

Photography: The Curse of Having to Be Different

Alexey Brodovitch, art director of *Harper's Bazaar,* gave courses in photographic creativity. His principle of teaching was: "Never show me anything I have ever seen before." What a destructive and unhelpful concept! How can it help a photographer be more original if he says to himself, standing before his subject: "Now I must be original?" Such a self-assignment would be constipating. Those who do original work in any field do so because they mine themselves deeply and bring up what is personal.

Flaubert wrote to de Maupassant: "To express what one wishes, one must look at things with enough attention to discover in them what has never been seen before by anyone else. That is what is meant by originality."

One of the penalties of straining to be different is that one ends up doing tricks and stunts. I have over and over seen what happens: a commercial photographer finds a newish and saleable photographic effect. For a short time he lights up the sky, and then as quickly fizzles out. William James knew how dependable that old girl, Success, was. He named her "the bitch goddess."

The futility and tragedy of this trying to be different is that it shuts off all possibility of making a personal statement. And there is nothing to be sneered at in making a modest, personal statement. Think of all the small, unmountainous poems that have lasted and nourished. No one knows who, in the sixteenth century, wrote these four lines, but they are still remembered after four hundred years:

O, Western wind, when wilt thou blow,
 That the small rain down can rain?
Christ, that my love were in my arms
 And I in my bed again!

Fledgling photographers in considerable numbers drift up into Vermont to show me their work, as if to ask a blessing from the patriarch or to seek a key to open the door to successful creativity (whatever "successful" means to them). I am far more able to tell them where the key does *not* lie — certainly not in technique nor in aesthetics nor in clever self-promotional ideas for photographs. If there is a key, it is of Greek manufacture: "Know thyself." Obviously no more valuable photographic ore can be mined

from a man than is in residence, and it is helpful for a photographer to know where to dig and where not to dig. The painter Edward Hopper said: "The work's the man; you can't get something out of nothing."

Ansel Adams is a fine example of a man's work being the man. Just as his photographs are grand and over-life-size so is he. I once had dinner at his house when he lived in San Francisco. He drank, and ate, and roared ideas and opinions like Rabelais's Gargantua. After dinner he sat down at the piano and thundered Bach. When he moved down the coast, I wrote him that I knew the reason for his moving and selling his house: his Bach-playing had shattered the foundations of his house. His photographs thunder in the same way.

To the extent that a photographer tries to make his work anything but what he is, he waters down whatever of value he has to give. I keep telling photographers (without effect): "Nothing is so certain to defeat your achievement of what you think is success as your pursuit of it."

Horse Sense Photography

When I resumed commercial photography I found I was least unhappy when photographing solid, practical things like trucks for General Motors. For one thing, the art director of the agency for General Motors was one of the few courageous men I ever met in this field. He once needed a photograph of a truck meeting a Buick in the desert near the Mormon town of Dixie in Utah. He showed me his sketch, which had just been approved by a committee of tough, overweight executives — then crumpled it up and threw it into the wastebasket, saying: "None of

us has ever been in Utah, and it isn't going to look like what they approved. So go out and photograph what's there." I was once with him in Detroit when he showed the head of a General Motors advertising division a huge color photograph I had taken for the next ad. The executive found a lot of small, carping criticisms of my picture. The art director took the picture right out of his hands, saying: "You got out of bed on the wrong side this morning; I'll bring it back tomorrow." But this sort of lèse majesté was the exception.

Uneasy Lies the Head (and Other Parts) of the Advertising Photographer

I have led an intermittent creative life: working for a few years at earning money by doing advertising photography; then, when my digestion and brains gave out, I'd either make still photographs or films for myself. When the money gave out I would go back into advertising.

For some years my former wife (a photographer) and I had a studio in my home where we photographed men smoking cigarettes and drinking whiskey. David Vestal, a lovely photographer and writer on photography, was our assistant. When the work I had to do was stupid and boring, I would get low in spirits, and David Vestal would be most supportive. He would locate in each job some technical or quasi-aesthetic problem to revive my flagging spirits to the point of quasi-interest. I owe him much.

I certainly did not escape some deterioration of my feelings, brains, and digestion. I made some money, but, as they say out in Hollywood about the big salaries, it was Confederate money.

Up from Purgatory

I guess I must have dumbly and unconsciously sought for a less painful way to use my camera to earn my keep. A few times in my life I have held long-term jobs which took only two to three days a month to support myself. I recall vividly that just as the big depression hit I telephoned home to say that I had a three-day-a-month job on a women's magazine at a salary of $750 a month. In those days that was fair money, since our duplex on the East Side of New York cost less than $200 a month. We owned an ancient Cadillac roadster (a valuable antique if alive today) which had about two hundred miles on the speedometer, since it had been used only on sunny days in the summer season to drive an heiress around Newport, Rhode Island. I used the Cadillac to get me out to the country where there was a tree to photograph.

Picture Editor on the Sunday *PM*

The newspaper *PM* was like no other since Gutenberg first set type. In the late thirties, the Sunday editor, William McCleery, persuaded me to edit two to three pages of photographs each Sunday and to write the captions. I didn't think I could write, but McCleery pushed and shoved, so I said I would try. I still remember and feel most proud of a caption I wrote which earned me the boos of the old-time reporters and rewrite men. Under a photograph of a mother and father Percheron and their offspring I wrote: "Draft horses are more susceptible to colts."

The pages were intended to draw the attention of the general public to unusual photographers and what they were saying in their work.

These pictorial essays had as subjects everything from what was happening in the world to how photographers saw people. We did three pages titled "Why France Fell" ,with photographs by Lisette Model of the rich of Vichy. Another time we hired a nice-looking girl to go to the six most famous portrait photographers in New York to have herself photographed. Some did her as a glamour beauty and some as a well-to-do Westchester matron. Murray Korman, who photographed the night club entertainers and the striptease artists, made her look flashily Broadway. Before he snapped the shutter, she told me, he would say to her: "Let's see your eyes, dear, all four of them." He would demonstrate his meaning by arching his back to show her he meant her to push out her bosom. The point of the piece was to show that you became an entirely different person, depending on who photographed you.

This was another of the three-to-four-day-a-month jobs, which gave me time to photograph or film for myself.

Steiner's Ethical Pharmaceutical Advertising

In my next few-days-a-month job I was in charge of advertising for a most ethical drug manufacturing company. I would photograph the Ph.D.s and workmen and the processes that interested me, and write copy to suit. I did not have to write that our drugs would cure all ills, the work was sufficiently challenging to hold interest, and the people I worked for were understanding and appreciative. I remember that my immediate boss would ostentatiously not look at my expense accounts when I presented them, but would imme-

diately scratch his O.K. His refusal to check my honesty placed a terrible moral burden on me. I seldom ordered steak and always paid for my drinks myself. This job went on month after month for some four years, enabling me to work on my own photography.

A Full-Time Job Without Horrors

There was another kind of earning a living with a camera which I found un-nervous-making and with enough challenge to hold my interest. This was in the field of public relations. This differs from advertising, where the client pays enormous sums for the newspaper or magazine space in which to sell his goods. In public relations one finds something sufficiently interesting about one's client to win free space in the news columns. Here there was no art director boss. I found my own subjects and made the decisions in photographing them. Clients had little idea of what should be photographed or how and usually were happy to leave such matters to me. My photographs often went into trade papers where the editors usually had to make do with brainless photography. They were delighted to receive photographs which had a point or a touch of humor. My clients were happy to get free space without paying for it, so everyone was happy.

What made this kind of work pressureless was that there was no competition. The typical public relations photographer does not bother to think about the end use of what he does. He is happy to photograph anything pointed out to him by the client, but he has no interest in his subjects beyond their earning him five or ten dollars per picture.

How Good to Be Able to Say to One's Client: "I Am the Doctor"

My clients in public relations photography had been in the habit of getting the maximum amount of work out of a photographer in exchange for a day's pay. As soon as a photographer arrived on the scene he'd be directed to his first subject. To break up this "let's-get-photographing-right-away" syndrome, I would not bring my camera to the job for one or two days. I would spend my time looking over the situation, trying to find out what photographs should say that could be helpful. For example, in almost every case in which the client made something out of metal, he would show me his thirty to one hundred drill presses in a row, and would want them photographed. I would ask if his chief rival did not have just as many drill presses, undoubtedly made by the same company in Bridgeport, Connecticut. I would ask what his company did with its drill presses that was better than what his rival did — maybe I could photograph that difference.

For example, in one plant, which manufactured miniature ball bearings, the tiny balls were so perfectly round and precise that a test tube the size of a forefinger filled with such balls was worth a small fortune. So, instead of photographing the room in which the machines made the balls, I photographed the filled test tube held in the hand of a surgically clad workman. No magazine would print a photograph of meaningless machinery, but a test tube full of gem-precious metal balls had interest.

There were times when I neither photographed what a company made nor how they made it. Once at a glass company I photographed a Bohemian glass blower making a glass ball containing colored glass flowers during his lunch hour. My photograph was intended to say that the workmen were artisans — that glass blowing flowed in their veins — not just men earning a wage. The advertising manager was so dull-witted as to tell me: "But we don't sell glass balls with flowers inside."

A Rabbi Out-Moseses Moses

Sometimes amusing problems came up. There was a matzoh factory in the Middle West which had the serious accusation made against it that it was dirty. I went west to find that the factory *was* dirty. I explained to the client that I could not photograph it as clean. I did make a few photographs in the laboratory and in the kosher modern test kitchen, which was spotless. I had what I considered a splendid idea. A kosher test kitchen does not mix meat products with milk products. In fact, it does not even mix the dishes for cooking or serving. I had a panorama camera which would sweep across the whole test kitchen, so I asked the kosher home economics lady to put all the meat food on one side of the room and the milk food on the other. My idea was to run a dotted line through the center of the superwide picture to say: "East is East and West is West, and never the twain shall meet."

Just as I was about to snap the shutter, the factory's inspecting rabbi walked in to find out what was happening. I explained my brilliant idea of the separating dotted line.

"No! No!" the rabbi shouted, "I am so orthodox that when we print a cookbook I do not allow that a photograph of a milk dish be placed opposite to the photograph of a meat dish, so that

when the book is closed they touch each other." Cookbooks and the possibility of meat and milk photographs were not central to Moses' concerns as he led the Children of Israel across the Sinai desert some thousands of years ago.

Public Relations Photography — Not the Worst of All Evils

To come back to public relations photography: it is far less oppressive than advertising photography for the photographer. Both are run by word-minded people, but whereas advertising is run by men who somehow didn't manage to write the great American novel, and have a need to compensate, public relations is run by former newspaper men who are making more money than they did on the editorial desk or on the police beat. If they try to tell a photographer what to do, he can tell them to be quiet, that he is the doctor and knows what needs doing. Also, in advertising there is always the art director, often a disappointed artist. His position is un-easy: part way between the money people, the word people, and the sales people. This does not make him a secure person to work for. And in advertising the client pays millions for the space into which photographs go. In public relations the space is free, so if a photographer's work is sufficiently interesting to win a lot of free space, the client is delighted. He does not complain, as did one of my advertising clients, that the model I selected looked like his Uncle Ben, and when he was a boy he hated his Uncle Ben. This was hardly a factor I could have been aware of when I selected the model.

The picture in this book of Gypsy Rose Lee and her girl-act illustrates how free a photographer can be when doing public relations work. The photograph was fun to do, but serious for Gypsy — she had to wear a costume weighing seventy pounds on a hot day, and it took her two solid hours to make up. But she knew the value of publicity and was willing to invest in it. Since Gypsy's acts all kidded sex, I could kid it in my stage setting and direction.

I got to know Gypsy, who lived a block away from me. My daughter, Toni, when small, used to play with Gypsy's son, Eric. Toni used to be frightened when going through Gypsy's living room, which was filled with terrifying surrealistic paintings and one superenormous nude by the ridiculous Frenchman Bouguereau. I once asked Gypsy how the almost twice life-size monstrosity got on her wall. She told me that after the opening night performance of Mike Todd's *Star and Garter,* in which she played the lead, they went to Sardi's to await the reviews. When they proved to be rave notices, Mike produced from his pocket an emerald bracelet for Gypsy. They then did the round of night spots to receive the congratulations. On the way home to Gypsy's house, she turned to Todd and asked: "Was it insured?"

He answered: "So, you've lost it?"

Gypsy suggested that they go back over their long night's trail from Sardi's in search. Todd sarcastically asked her if she expected a man would be waiting at the corner of Broadway and Forty-second Street with the bracelet in his hand, hoping the owner would return for it. Next noon there was a telephone call at Gypsy's from the Todd office to ask if Miss Lee would be home around four. At four a team of strong men carried in a ten-foot-high crate with Todd bringing up the rear. Todd would answer no questions while

the movers opened the crate. Inside was a nine-foot-high nude in ornate frame. "There," said Todd, as he made his exit, "God damn it; lose that!"

False Start toward Hollywood

A warm-hearted attorney friend one day brought me together with a strange man and an odd adventure on the way toward Hollywood. The strange man's name was Jacques Griniev. He was an exceedingly thin Russian — always dressed in funereal black. His credentials were that he had been connected, as producer, with one of the truly great classic French films, *The Passion of Jeanne d'Arc.* I would think that the term *producer* in France meant only the money raiser, since he never talked about film except as a way to financial glory.

I had for some time been harboring an idea for a film about a man's trek across the whole United States to murder someone on the far coast. As he crosses, the people and the look of the land affect him so that he no longer has a need to murder. It was highly unreal, and overly moralistic. Obviously, I conceived such an idea because it would have given me an opportunity to film the landscape as a protagonist in the story.

Griniev was a grim man of mystery. All through our negotiations I never did discover where he lived in New York, and I never had a phone number for him. He would burst out with the most extraordinarily emotional statements: "Relph, you hev in your stomach bebe, which I am going to put on scrin for world to see." And: "Relph, you are my brozzehr: what you know I know; what I know you know." And the latter in spite of my never knowing his phone number.

One day he brought in a new element, a partner. He was Boris Morros, whom my attorney friend sometimes addressed as Morris Boros. He had been trained as a violinist and had been for years in charge of Paramount Studio's music department. Boris was the exact opposite of Jacques — roly-poly and full of jokes. He boasted that every day of his long married life he'd brought a new joke home to his wife.

Contracts and Rasputins

Boris, my lawyer friend, and I sat down to draw up my contract to direct the film and to supervise the writing of a script with which to interest financial backing. Boris kept bargaining, trying to reduce my salary until my lawyer asked: "Mr. Morros, will the difference you're arguing about show up in the net profits?" His question about the net shamed Boris, and settled my low (for Hollywood) projected salary.

At the contract signing, Boris kept fingering something hidden in his pocket. I asked what he was doing. He pulled out a string of prayer or worry beads, which he used when nervous. He told me their supposed origin: "Dizz bids waz give me by za mad monk Rasputin. One day I am playing beautiful music for da Tsar when who should come in but Rasputin. I vaz verring a beautiful embroidered blowse, and Rasputin ask me: 'Who embroider zis beautiful blowse for you?'

"I say: 'Da amprass hersalf.'

"He say to me: 'Boris, you dog, you lie, but except you make sahtch beautiful music I cut your troat. But Boris, you make sahtch beautiful music, teck dis bids, kip dem wit you alvehs: vill bring you good lahk.' "

And then Boris would add: "Ent I ain't bin doin so bedly."

The Boat Begins to Leak

The two partners went off to the West Coast. I hired two girls to do research for the film at minuscule wages, and paid them out of my own pocket. I got no answers to my letters, telegrams, and attempts to telephone Boris and Jacques. After a month I had to let the researchers go. Through my lawyer friend I sued the partnership and won since no one appeared to defend the suit. But we sued in New York state and the partners were safe in Hollywood. However, my lawyer friend said he would remedy that.

It seems that years before Boris Morros had brought together the always feuding and then separated Laurel and Hardy to make a film. About the only virtue of the film was that Stan Laurel had not forgotten how to stick his finger in the eye of Hardy (or was it the other way around?) to make him retreat from combat. The film was not the financial success of *Gone with the Wind*. It lay unused in the vaults of R.K.O. My lawyer got a court order to examine R.K.O.'s books to see if there were earnings we could attach. Naturally there were not, but an accountant was hired to keep making a weekly nuisance in the R.K.O. offices, demanding to see more and more books until R.K.O. brought pressure on the partners to stop the disruption in their accounting office.

"Louis, by Chence"

The next move was a phone call from Boris, who had returned to New York: "Relph, come, we

hev nize lahnch togezzer in 21, ent we seddle dis." At 21 we had just sat down when Boris popped up and heartily greeted a friend as he came up to our table. "Louis, by chence, vat are you doink here? Come sid down and it wit us. Mit my frent, Relph Steiner. Relph, mit my frent, Louis Nizer."

Nizer, one of the country's outstanding criminal trial lawyers with a long history of winning impossible cases, was having no part in the surprise meeting nonsense. He sat down and, before ordering his drink, started off in a most severe, judicial manner: "Mr. Steiner, why are you persecuting my client?"

I opened up my soul and gushed forth the injustices done me, the promises unkept, the unanswered letters and telephone calls, and the accumulated bills for research. Lawyers become hard-of-hearing when an opposite point of view is proposed. Nizer said in the coldest and most threatening of tones: "Mr. Steiner, if you persist in your persecution, I will personally see to it that you never in your life receive employment in Hollywood."

Ordinarily I am first cousin to Alice Ben Bolt and, with her, "tremble with fear at a frown," but this threat was so preposterous that I burst into laughter. I left the table and lost the only chance I ever had to eat a meal in 21.

The next move of the partners was less threatening: a telephone call from Jacques, who was also in New York. He wanted to call on me at my home. He arrived, still all in black and thinner than ever. We sat down, and he started: "Relph, vat is diz businezz of lawyers between gentelmens?" He dug into his jacket pocket and brought forth a handful of brand new hundred-dollar bills. I assume that, like Boris's Louis Nizer, they came into his pocket "by chence."

They made quite a pile on the table. I wouldn't touch them, and told him to see my lawyer. I finally got, I think, fifteen or twenty of the bills out of the contretemps.

Hollywood, City of the Angels, Here I Come

A year or so later I happened upon a book by Hiram Percy Maxim, the inventor of the Maxim silencer for guns, about his remarkable, eccentric, inventor father, Sir Hiram Stevens Maxim. The book had been published some fifteen years before, but no one had considered it as the basis for a film. So I invested a few hundred dollars in an option for the book's use as a motion picture, and took it and myself to Hollywood. I had been warned that if within six months I was not earning at least three thousand dollars a week I was to return to New York. I was told: "If you earn less, no one in Hollywood will be able to hear you." That was good advice, but I could not hear it. What I wanted was not money so much as to make films on location — against real backgrounds and about real life situations. But that never happened.

In Hollywood I, in turn, sold six-month options on "my" book to film producers. One producer was saddled by a tiny, little, old lady, who dressed in Lanz of Salzburg children's clothes — jumpers of bright green with huge bright red hearts. As the widow of a rich vegetable grower in the West, she represented the money in the setup. She was known as "the lettuce queen of Colorado." I never in six months heard her say one word. The producer never used "my" book, so the rights reverted to me.

The Crying Rabbi

I then sold the film-making rights to a producer, who many years before had been assistant rabbi of the temple in Cleveland where I'd been sent to Sunday School. His brothers owned a string of movie theatres, so that made him a producer. He often made financial deals more favorable to himself by breaking down in tears while in negotiation, so he was known as "the crying rabbi of Hollywood." My contract specified that I was to work on the script as a writer and as assistant to the director. Another writer and I developed a script which followed the book closely. Just as we finished the script, the rabbi-producer discovered that Claudette Colbert had no commitments for a few months, and put her under contract. Now, more writers were hired to hurriedly rewrite and to change what had been a life-with-father story to a life-with-mother story. Think what might have happened if the producer had been able to put Lassie under contract.

The thrown-together script and the thrown-together film ended up in a series of disconnected episodes making small sense. Because the head writer was highly Irish there was in the film an obligatory scene: mother dying with father and the two children at the bedside weeping straight out of Landseer, without the dogs. Mother did not finally die. If you pay Claudette Colbert her kind of salary, you do not kill her off part way through the film.

Audience with King Louis, the M.G.M. Lion

Some months later I was given an audience before Louis B. Mayer, who sat behind his desk, high on

his circular dais. He asked me what I had done. I started my history in film: "I have made . . ." Then he cut me off short: "My boy (I was then almost fifty), let me tell you how I got where I am." So for thirty minutes I listened to a Horatio Alger story of his rise — all the way from being a salesman in Gloversville, New York. At the end I was dismissed with another "My boy" and "You'll go far." How could he know? And would "far" be his far or my far?

Tears and Johannes Brahms

I became an assistant at M.G.M. to Clarence Brown, famous as the director of early Garbo films and of *National Velvet*. At the time I was hired, Brown was off to Florida to film *The Yearling*. I was left to select a writer and to work with him developing a script for *The Song of Love* (about Robert and Clara Schumann and Brahms). A once-famous writer, but long out of favor, was proposed to me. But I turned him down because he tried to bribe me with hams and butter (it was during war rationing). Instead I hired a young Hungarian (how could an American write about three Germans?). Every time he turned in pieces of his script the English had a different *"Mittel-Europa"* accent. I finally discovered that he in turn had hired several other European writers to do his work for him in exchange for gas stamps.

Every week I would confer with one of the superproducers about progress on the writing. He would interrupt my reading of our script by telling me the "true" story of Clara Schumann's rejection of Brahms's marriage proposal out of loyalty to her dead Robert. While he recited the story, he wept and wept. I kept wondering why his tears at Clara's refusal of Brahms.

When Brown came back from Florida he explained the producer's tears. Many of the oldish producers had long since divorced their wives of early marriages and had married much younger women. This producer was weeping as he imagined his wife, a youngish widow, out of loyalty to his memory, refusing the proposal of some handsome youth.

Naturally none of the realistic research into the lives of the Schumanns or Brahms was used. The film was titled *The Song of Love*. It was purest saccharine and an insult to the music and the lives of all dead and living composers.

Armed Defense of the Kingdom

One afternoon Clarence Brown asked me: "Do you want to see something?" The "something" was strongly emphasized. We drove out Hollywood Boulevard. As we passed along the business section, he said: "Once I owned from here . . . to . . ." we kept going and going ". . . to here." We drove a long time out into the country. When we came to crossroads with no traffic lights and with some cars crossing and some waiting to cross, Brown would step on the gas and drive straight through — it seemed to me without looking right or left. He explained: "I flew a plane in World War I; this Continental has a special engine; it's heavier than any of those other cars; and I have more insurance." The "more insurance" somehow did not reassure me.

We finally arrived at a high-walled estate surrounded by mountains. He tooted, and the massive gates were opened. Inside was a castle — a real castle — but of low-grade Hollywood architecture. Brown announced: "I have a kingdom here; the mountains protect me on three sides; it

is easily defended. I bought it from King C. Gillette, the safety razor maker."

Inside the castle our feet disturbed years of dust. The bathrooms were marble, the faucets and fixtures gold. The curtains hung down in shreds and the heavily upholstered, baronial chairs were mice condominia. We went into the cellar and then down into a subcellar. There at the end of a long cement tunnel we came to a safe door set in the wall. Brown asked me to turn my back as he twirled the safe door dials and swung the door open. Inside the vault were cases of rifles and ammunition, heaped cases of food and liquor. Brown announced: "I can withstand a siege a long time here."

"But who would attack you?"

"The Communist writers."

The Communists of that day bore no resemblance to the Weathermen of today. They used words like "revolutionary," but they were words empty of any possibility of action. And the Hollywood Communists wore even cleaner shirts and were less militant than the rank and file. Their main duty was to pay tithes to the party headquarters in New York, where they were known in military terms as "the Caviar Front."

I recall hearing one far-left writer boasting to another at a Beverly Hills party that he had slipped some leftish propaganda into a film under the nose of a watchful right-wing producer: "Did you catch that bit where the white man tips his hat to the colored lady?" Writers on the left were too full of Mike Romanoff's expensive food to man the barricades outside Clarence Brown's castle.

Me, a Hollywood Producer?

I finally ended up at R.K.O. Studio with a piece of paper saying I was a producer. But a producer is one who produces something, and I produced nothing. Hollywood was for me a region in Dante's Hell where the ground always shook under my feet. For security of mind I should have kept a camera in my hands — something I knew. I was never meant to be a writer-executive — just a seeing-eye man.

After four years I returned to New York to do what I was intended to do: to work with my eyes and hands behind a camera. I had gone west on the Santa Fe Super Chief. I came back feeling neither super not chief-y — just one of the Indians, but with enough scalp left to plunge back into photography.

I had learned my lesson so well that when I was later offered a fee of fifty thousand dollars for two months work on a Hollywood film I turned it down with no qualms. It was not my habit to turn down work at almost a thousand dollars a day, nor were there during my life many knocking at my door with such offers. But by the time the offer was made I was again hoping to earn a moderate keep with my camera, and I was not about to go butterflying after overbright flowers again.

Walker Evans Saves a Life

Of course I got back to a world that had forgotten me. There were now twenty times as many photographers wolf-hungry for every job. The portfolio I carried around was five years old — it might just as well have been one hundred. Walker Evans, then a *Fortune* magazine editor,

sort of saved my life by offering me the chance to make a full-page photograph in color every month of the top men of the biggest U.S. corporations. On my first job — to do a portrait of the new president of General Motors — I discovered that my photographing for *Fortune* put me a peg or two higher than the head of General Motors, and I never found in the several years a big executive who wasn't anxious to do what I asked in order to get his face on the first page of *Fortune*.

Walker would often accompany me on my trips around the country for *Fortune*. But he never came with me into the offices when I photographed the heads of industries. Nor did he ever over the years comment pro or con about the quality or interest of my photographs. I think he just enjoyed travel at *Fortune*'s expense. He carried with him an ancient battered Leica but no extra lenses, filters, or meter. The state of the camera and the lack of accessories was Walker's way of thumbing his nose at equipment maniacs.

In a later year Walker exploded with wrath when asked how much Stieglitz had influenced him. Nothing could have been further from Walker's purpose than Stieglitz's romanticism. Walker used to say that I had had an influence on him, but I assumed that it was the teakwood view camera and the row of German Satz Linse in their red velvet-lined case that I gave Walker about fifty years earlier that made him say that. Later, John Szarkowski reported in his introduction to the Museum of Modern Art's book of Walker's photographs: "It would seem that the one living photographer whom he awarded a grudging respect was Ralph Steiner, whose work in the twenties did anticipate in some respects the latter work of Evans." I have just finished making, for portfolios, three hundred prints from ten negatives made in the twenties, and I guess I can see

some relation between the follies and foolishnesses I picked as subjects and the unserious subjects that fascinated Walker. These were often naive signs. When, a year or so before Walker died, he was artist-in-residence at Dartmouth, he and a professor friend used to venture out at night with a hacksaw to "liberate" the signs Walker admired.

I don't think in all the years he worked for *Fortune* Walker ever allowed his name to appear on the magazine's masthead. He appeared only seldom in his small office — once or twice a month. As I remember it, there was nothing in the room to make it Walker's: a standard chair, desk, lamp, and no name on the door. I once asked Walker how he operated since he seemed so little connected with the magazine. He told me that twice a year he would take the managing editor out to lunch and would suggest picture story ideas. They were almost always accepted. And the ideas were usually those which would include a trip that Walker wanted to take. For one piece Walker made photographs from his Pullman compartment window as the train crossed the United States. Another piece took Walker to London to photograph the typical British businessman with furled umbrella and hard derby on the street. As research, I'm sure he ate in the very best restaurants. Walker always wrote the copy for his pictures and had a most highly personal style. Though he produced only a few pieces a year, they gave a special flavor to a magazine devoted to business, profit, and loss.

Now, as I write, the never-very-happy, usually with-chip-on-shoulder Walker has left the scene. *"Raste Krieger, der Krieg ist aus."* He created a kind of photograph we will always think of as special and belonging to him. He was in his person and in his work very much his own man.

"Good" and "Great" Be Damned

When I had a show of photographs in New York, the *Times* photographic reporter wrote: "Steiner is good but not great." I am not pure angel; after making a photograph I suppose I am as happy as the next fellow to have people enjoy something in it and to have them say so. But of this I am certain: if ever I thought to be "great" or worried that I was not "great" while making a photograph, my shutter finger would be hamstrung (a fine mixed metaphor). Abraham Lincoln had the right idea when he answered an old lady who cirticized his handling of the presidency: "Madame, every day I try to do the very best I can."

I have solved — at least for myself — the conflict between the need for praise and the need to think only of my subject and myself when making a picture. I tell students that if I were the last person on earth I would still photograph. When I am photographing I am not communicating. When photographers speak or write about the act of communication, I have no idea what they are talking about. But when I have completed a print which pleases me, then I rejoin the human race and am only too happy to have it appreciated.

E. M. Forster said it all when he wrote about the creative act: "In it a man is taken out of himself. He lets down as it were a bucket into his subconscious, and draws up something which is normally beyond his reach. He mixes this thing with his normal experiences, and out of the mixture he makes a work of art." When I am photographing something which gives me great satisfaction, I sort of wish I were religious so that I could thank a God for having introduced me to my subject.

Minor White, Post-Transcendentalizer and Practical Man

Minor White: how difficult for me to say who and what he was! I saw a very different side of him from most people and certainly from his pupils. When I lived in New York City, Minor made our house his headquarters when he came from Rochester. He always brought a print as a house present. Some of the prints were a mystery to me and had too much blackness for my nature. But a lovely one, which I think is of ice crystals (one never asked Minor what the subject was), looks like the sound of Bach on a harpsichord.

Minor and I got along very well together — at least I can say I found Minor and his spirituality no problem. Undoubtedly he saw me as far too earthy to bring in his stars or other outworldly subjects. With me he was always "plain folks." We'd sit and drink and talk and make jokes. He was a good laugher and a good drinker.

It interests me that these days some people see a relation between Stieglitz and Minor, as people and in their work. I always thought they had a relation in that they both did what I call post-transcendentalizing of their work. When a bowler twists his body after the ball has left his hand in order to influence the direction it will take, that is called "body English." Quite a few photographers give their prints "body English" after they are finished and mounted. They talk up their prints and add value and meaning with words. With photographers such as Stieglitz and Minor, "body English" seems a vulgar term, so I call it post-transcendentalization. Stieglitz's method was to elevate his prints by lowering the onlooker: "No one can possibly understand what I have put into this photograph." It was a seesaw

operation which left the onlooker or possible purchaser humbly at the low end of the seesaw and Stieglitz and his print at the top. Minor's self-elevation and post-transcendentalization were far quieter, and the other party being lowered had the sense there was a foreseeable ending to the words some time in the future. But Minor's spiritual-Boleslavsky-Zen-astrology could leave one with a head filled with lighter-than-air milkweed down.

In spite of Minor's relationship to astrology and Eastern religion and Boleslavsky, he could be bone simple and most helpful, even to beginners. He attended a class I taught and spoke to each student about his work. I had told him in advance that he'd have to abstain from all mysticism. Minor would look at each student's work for two to five minutes, and then talk about what he saw in each. He gauged his words to fit the level of each student and was down-to-earth practical. He was far more helpful than I could ever have been.

I am no slow motion film of a sloth myself, but I have never seen any creative person with Minor's boundless energy. He earned his main living teaching in schools. He would come home after school to work with his private students. At night he would entertain and when the guests went home to bed, Minor would start work printing his own pictures. Then there was his editing of *Aperture,* his quarterly, and the writing of his books on technical photography. It is no wonder that his heart gave out all too early. Minor had many sides, but the one he sensibly presented to me fitted me; it amused, charmed, and stimulated. I wish the Minor I knew had been left to us in more of his photography.

"Oh, To Be Darkly Mysterious and Ambiguous"

There is a present vogue for making weird, darkly evil, or mysterious photographs. But sheer determination and clever invention toward the manufacture of weirdness will not convert the work of a normally happy, run-of-the-mill photographer into a ticket to fame and fortune, and it will certainly not give his work permanent interest. For that, what is needed is to have been born of a witch mother and a warlock father — or, lacking that, Spanish blood with Goya as a distant progenitor. The sinister, frightening nightmares of *Los Caprichos* were not the result of Goya sitting in a dark corner muttering: "How can I be different so I stand out?"

All too often, young photographers show me work that is dark, difficult, mysterious. I get the sense that what they do does not arise from a blackish unconscious, since they seem nice, agreeable, young men. I get the image of the smallest boy in the schoolroom wildly waving his hand in the air to get teacher's attention. This kind of photography has become so fashionable that a teacher of photography recently told me that he was approached by a student who asked: "Teacher, how do I get more of that ambiguity into my work?" When I tell this horror story to audiences of photographers, I hardly ever get laughs or expressions of shock.

In *Humboldt's Gift* Saul Bellow says: "You don't make yourself interesting through madness, eccentricity or anything of the sort, but because you have the power to cancel the world's distraction, activity, noise, and become fit to hear the essence of things."

I have a neighbor, a famous writer of short

stories and a teacher of writing at Sarah Lawrence, Grace Paley. I told her I was perplexed about what to say to young photographers who bring me blackish and mystical work for criticism. I asked her what she tells students who bring her such work in writing terms. Grace is a direct person; she said: "I tell them they are lying." That word "lying" bowled me over; it is so simple, meaningful, and true: when anyone makes a statement in words or pictures, false to his person, he is lying. I have not had the courage to use that word yet to a young photographer.

Nudity and Chicken Soup

It is entirely possible that my outlook is cramped by the orthodoxies of my day. There are some days when I am old, more than physically stiff, and more than a bit crabbed. And so my regurgitative mechanism rejects that the Museum of Modern Art sees fit to make an exhibition of photographs by a photographer of his nude, eighty-year-old mother making chicken soup. The recent gargantuan exhibition of Richard Avedon's portraits celebrates his ability to transform good, wise, and useful humans into decaying monsters. It takes little skill to light a subject to bring out the ravages of age; to wait until the subject looks his most dispirited or exhausted, and then to push the shutter; to print with excessive contrast, and thus twist the knife in the wound. It is hardly news that at birth we all begin to approach death. What is more worthy of statement is that many who are worn and gnarled are busily creating "life-enhancing" work, and, despite the slings and arrows of outrageous age, follow the admonition: *"Trotz Allem"* — in spite of everything.

If young, ambitious photographers counter that Avedon's latest show made a world's record (the largest show of large pictures) and that the author of nude grandma making soup has had three shows so far at the Museum of Modern Art, I offer in rebuttal that quite often felons get their faces and names in the newspapers and in post offices. It is folly for me to demand that all of what is created be affirmative. But it does seem legitimate to ask that, if negative, its target be what is amiss in the world. It could be that I oversimplify a complex issue; I see only that some photographers are adding to the world and some are subtracting.

It requires no great sensitivity to understand the revulsion of the younger photographers to a world in which a Vietnam war and a Nixon-Watergate despicability are possible. I can sympathize with the feeling that the world may be lost. But I see no relation between that despair and the photographic degradation of human beings for self-promotion. I think I smell Dr. Freud and hear the rattle of coins (thirty pieces) around the corner.

Why Films?

Why in the thirties and why toward the end of my creative life have I shifted from still photography to film making? I am not sure I know the answer. The shifts were not motivated by clear thinking, but more by feeling. I do not see film making as "better" in any way than making still photographs — except perhaps that its greater complexity makes for greater challenge. It may well be, as Minor White put it, that people who make things need "feedback," and there was too little feedback from my still photography. My

prints were hardly in danger of bleaching due to excess exposure to the light. For decades they sat speechless in closed boxes. Once Steichen gave me a show at the Museum of Modern Art in which I was billed as an old timer. I was about in my fiftieth year at that point. Then it was twenty-five years until the Witkin Gallery in New York put up all my old and newer photographs. I do not complain; I never pushed to have my work exhibited. And when I did have the New York show, the main feedback I got was bad news for the financial health of younger photographers. A number of my prints sold for what were to me surprisingly high amounts. But of all the prints sold to museums and individuals, only one was a new picture. Buyers want old work. Prints made in the twenties and thirties went for twice as much as prints from the same negatives made recently. This extra value of "vintage" prints has to do with financial investment instead of quality, since I am now far better able to make a good print than I was forty years ago. I felt like saying to buyers, "Please buy some photographs made in the 1960s; I promise to die very, very soon so their value will go up."

The preference for photographs made yesterday bodes no good for young photographers who would like to earn their living by making personal photographs. What seems to be needed is a potion which will give instant old age to the young.

Recent Film Making

All my recent film making relates to an almost lifelong interest in the enjoyment of seeing and in trying to help people toward it. All the later films come under the general heading of "The Joy of Seeing." These films are exactly the opposite of the typical didactic teaching films in which rules of perception are spelled out, and a voice tells the audience what is on the screen, what its meaning is, and why enjoyment should be derived from it.

On the contrary, there are no teachers' voices in my films — one film even makes fun of such an idea. My "theory of education" is that enjoyment can be learned but not taught as such. I think that the ability to enjoy can be gained only out of experience in enjoyment, and so I say that my films are based on education through inebriation — that is, drunkenness of the eye.

One film compares what can be gained from the wide viewing of mighty Niagara Falls with pleasures gained from looking closely at the moving jewelry of sunlit bits of water in the rapids above the falls. The film tries to make the point that bigness is not necessarily better than smallness.

Another film repeats a very short sequence of daytime Roman candles of white water against a deep blue sky six times — each time with most diverse music. The point of this film is that music affects our feeling, and what we see is considerably affected by what we feel.

Another film relates laundry swaying in the breeze to the feeling of classic Greek bas reliefs, vase paintings, and sculpture. Some grown-ups find this film difficult, but children, less logical, accept it with pleasure.

All in all, it looks as if I have either made or worked on about thirty films. All but two of them were short — ten to twenty minutes. In the recent "Joy of Seeing" series there have been eight completed. The last is called *Slowdown*. In it, slowly moving sequences of things I think beautiful alternate with blurred kitsch as seen from an automobile driven at 3,000 (yes, 3,000) miles

an hour. The music for the ultrafast sequences is horribly screechy and offensive. The music for the calm sequences (Bach, Couperin, Vivaldi) is a delight. I am trying to show the truth of a nineteenth-century French saying: "Nothing is so important to a man as the determination not to be hurried."

I own a lovely copy of an Etruscan figure of a man leaning on one elbow as he lies, completely at ease, eating. I bought it to teach myself the lesson I preach: slow down. I am trying to be more like Robert Frost, who, at the start of his first ride in a small plane, said to the pilot: "Don't go so fast that I miss anything. If you see any flowers, slow down."

As the mileage markers whizz toward eighty, I look back on what I have done and on what I have just written about the doing. My editor asks that I end by summing up with a survey of the creative influences on my work during my lifetime.

That I cannot do; there is not one-thousandth of an ounce of art historian in all my one hundred and sixty pounds. Those influences on which I can put my finger are not creative but moral, human, and economic. I end up asking how I should have used myself — how treated whatever talents I was given — what I could have been and could have accomplished had I not paid timorous attention to the wolf near the door. The wolf was never actually at, but only shadowing, my door from time to time. I envy photographers like Edward Weston, who seems never to have had wolf-fears.

I once met a foolish woman who was sad because she lacked the time to enroll in two courses: "Planned Happiness I" and "Planned Happiness II." I may be equally foolish wondering if I shouldn't have sought out a course in "What Shall It Profit a Man . . .?" I regret the half-life spent away from personal photography. I should have spent it pleasuring myself by pleasuring others with my work. But I am grateful for what there was of that, and this book is part of the result.

Above all, I feel lucky that I am still making pictures and films, and that I continue to be aware of the excitements of the visual world around me. George Santayana said it so simply and so well: "For birth and death there is no remedy save to enjoy the interval."

A Point of View: Photographs

The Early Twenties

I started in photography when nearly all photographers worried that they were not considered artists. It was held against photographers that they made pictures by way of chemistry and physics instead of through the hand of an artist. Today, on the other hand, a photographer would tend to duck if anyone threw the word "artist" at him. I did not do any thinking about what a photographer was supposed to be or to do, so this kept me free from thinking I had to be an artist. I suppose a bit of that envy of artists rubbed off on me second hand though, since the first three photographs in this book are soft focus, but they are not characteristic. (What an innocent time that was when photographers thought to become something like Impressionist painters by making blurred pictures. Some of them kicked their tripods during exposure while others smeared grease on their lenses!)

I not only didn't think about the style of my photography, but unless someone had held me at the point of a gun, I couldn't have said what my attitude was toward the stuff of the world. So I simply photographed what I liked or what amused me. This was hardly in keeping with Stieglitz's dictum that a photograph had to be an affirmation. What resulted did show some point of view, though fifty years later it does seem thinly humorous and hardly robust. But I unconsciously located material and an attitude which suited me as a twenty-year-old. When I teach photographers these days I do my best to get them to open themselves to who they are and to what in the wide world attracts them. When they have no natural bent, they often turn to technique for its own sake, to mystery, to ambiguity. I think I was fortunate to turn toward the slightly humorous; it at least kept me in general from trying to be a painterly artist or from trying to make earth-shaking statements.

These early photographs were made with a 4 x 5 Korona View camera and a rapid rectilinear lens — often on glass plates, because an old photographer had told me that you could never get the quality on film that glass plates assured. Of course, at this point I had no idea what "fine quality" might mean, but I lugged around New York City not only a heavy camera but a dozen plate holders and two dozen glass plates.

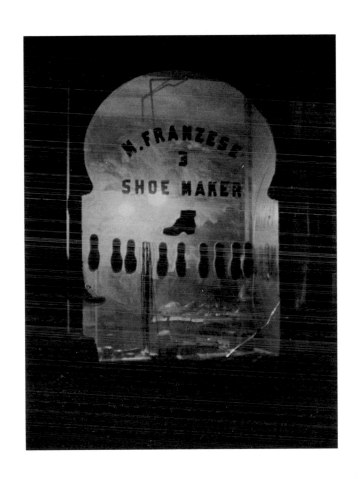

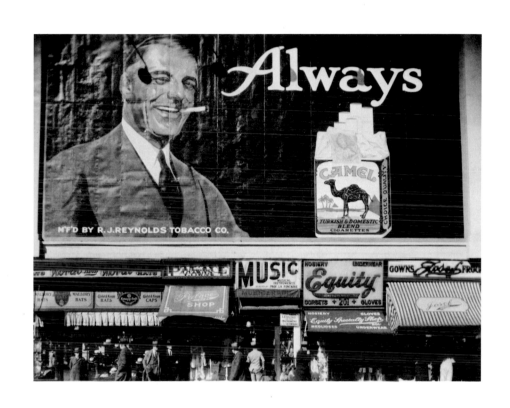

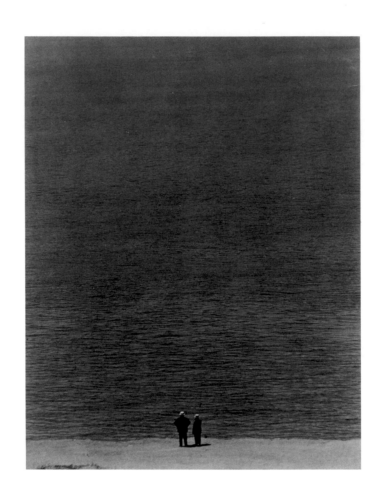

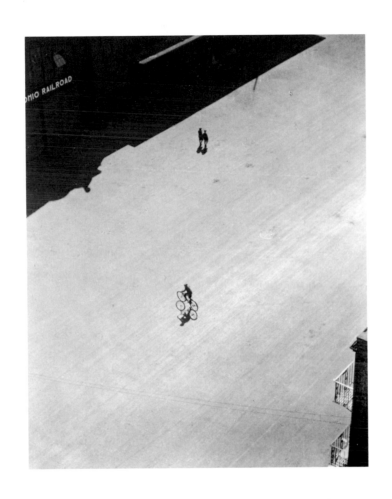

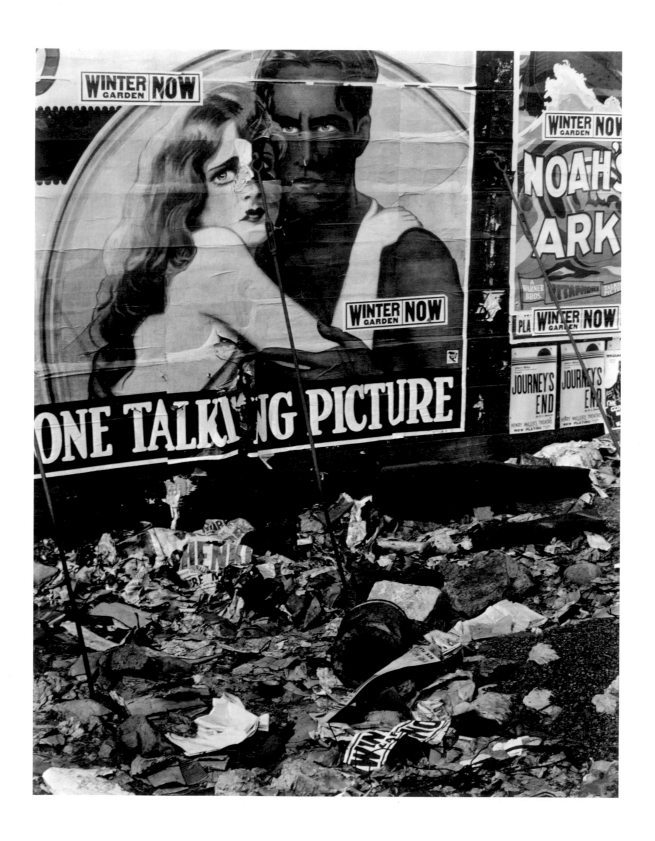

44

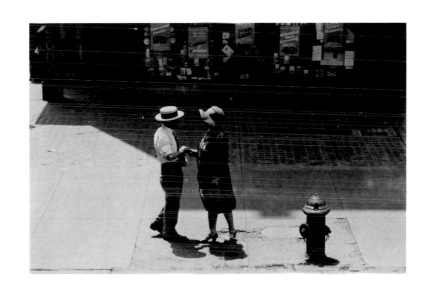

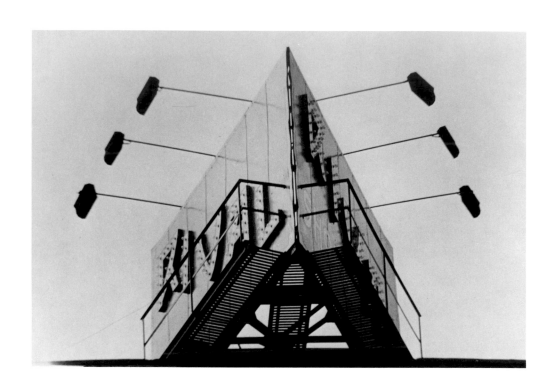

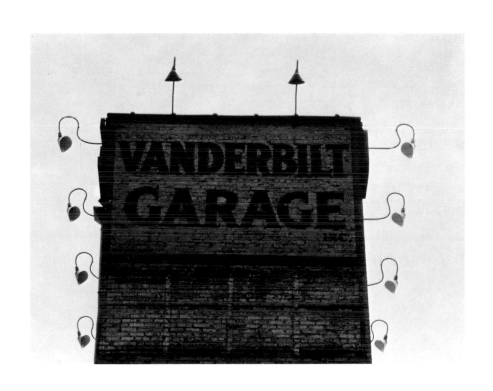

Post-Strand

This sequence is titled "Post-Strand" because the evening I spent at his house sometime in 1927, looking at his photographs for the first time, made me know I could not call myself a photographer. I do not think I was as impressed by his subject matter or his attitude toward it as by his technique. I had never before seen the tones and textures of the world so real and so rich on a piece of photographic paper. I knew just about enough to know that Strand had no technical secrets — no special developers and no magic, and that it was the ABCs of photography I needed to learn in order to make prints which were not the result of chance and would not be a disgrace to me. So I did not ask him what materials and methods he used. Instead I bought an 8 x 10 camera, took off for a summer at Yaddo, and spent twelve hours a day learning how to make negatives which would not fight me in the attempt to make the print I wanted. This was 1928, and, happily, sheets of 8 x 10 film were cheap, and I had had a three-day-a-month job which paid for film, food, and roof.

That summer I learned that if I could not get the print I wanted easily and directly, it was solely the fault of the exposure of my negative. So to get the prints I wanted I learned to make "better" negatives — negatives which would almost print themselves. In his *Daybooks,* Weston writes of his ability to make a negative which printed as he wished without effort. Today, if a negative does not print simply and easily I throw it away, knowing that much manipulation will not give me what I need. Photographers undervalue the use of a wastebasket in their pursuit of fine photography.

All that summer I photographed objects with strong textures — often waiting until the sun was at the best angle to intensify the feeling of material. But the whole summer was not spent doing technical exercises; when I saw things which amused me (such as the NEHI signs) I would stop to photograph them. It may be these things that Walker Evans referred to when he said I'd influenced him. He also photographed visual amusements. It is a grim world and can do with a bit of entertainment. After all, Papa Haydn was not above making jokes in his music.

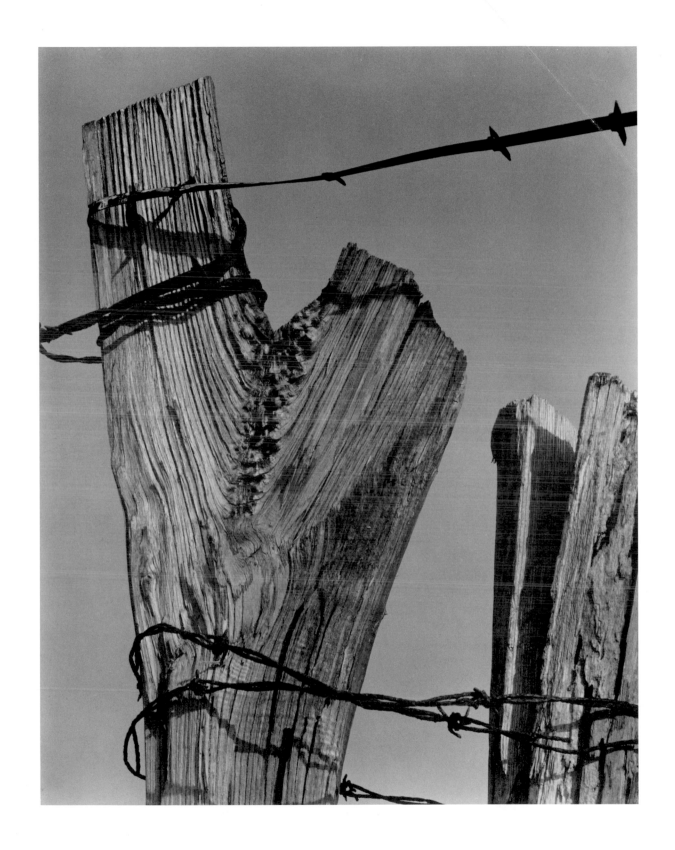

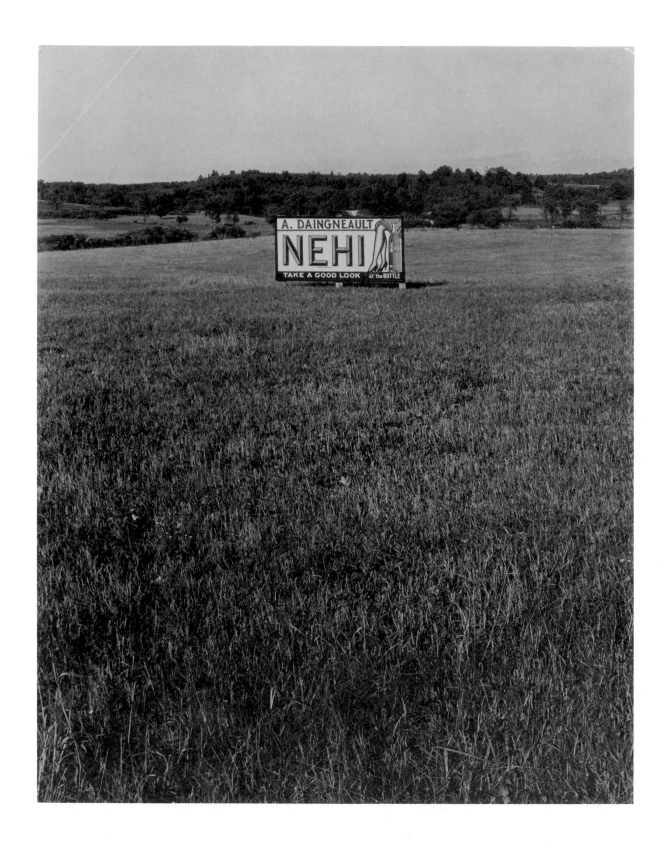

50

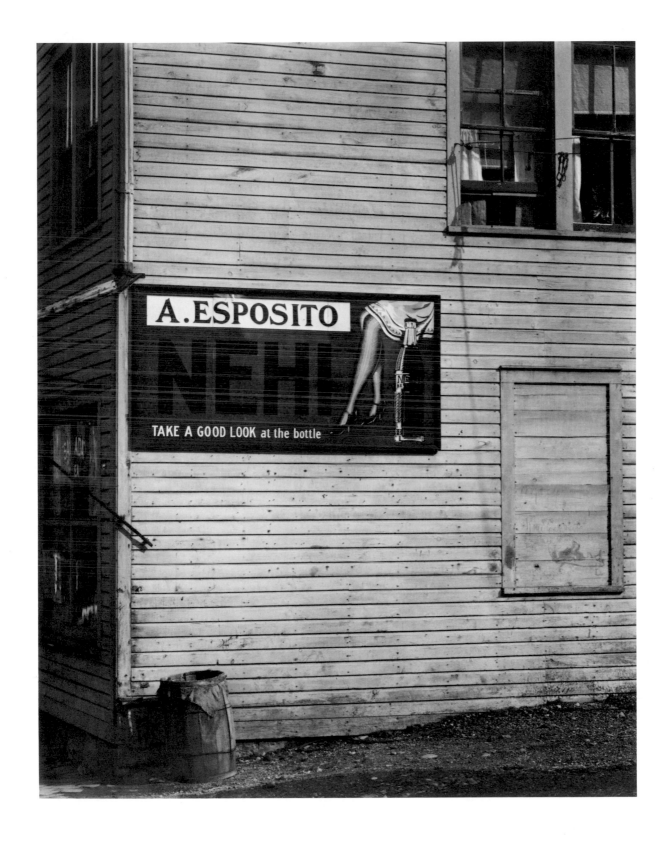

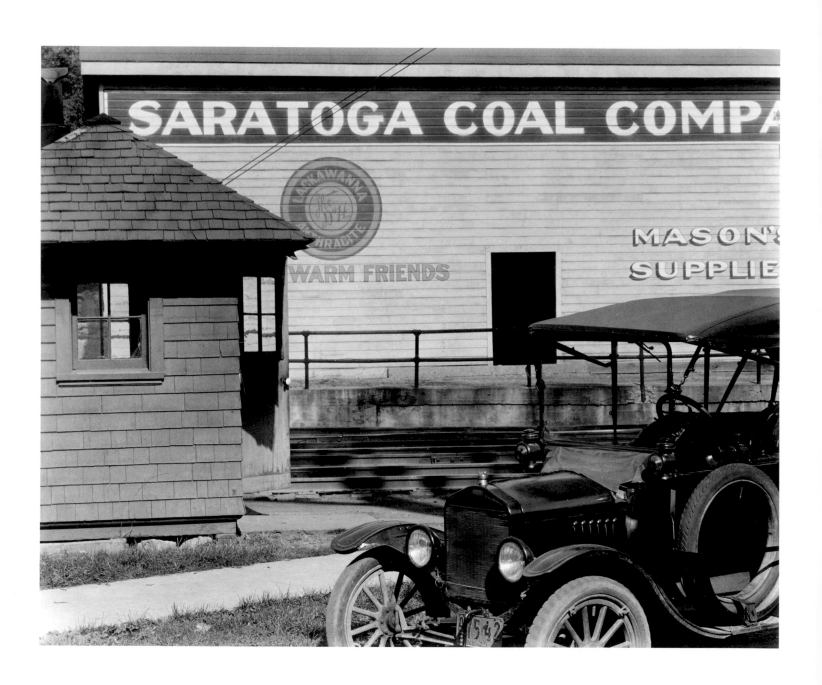

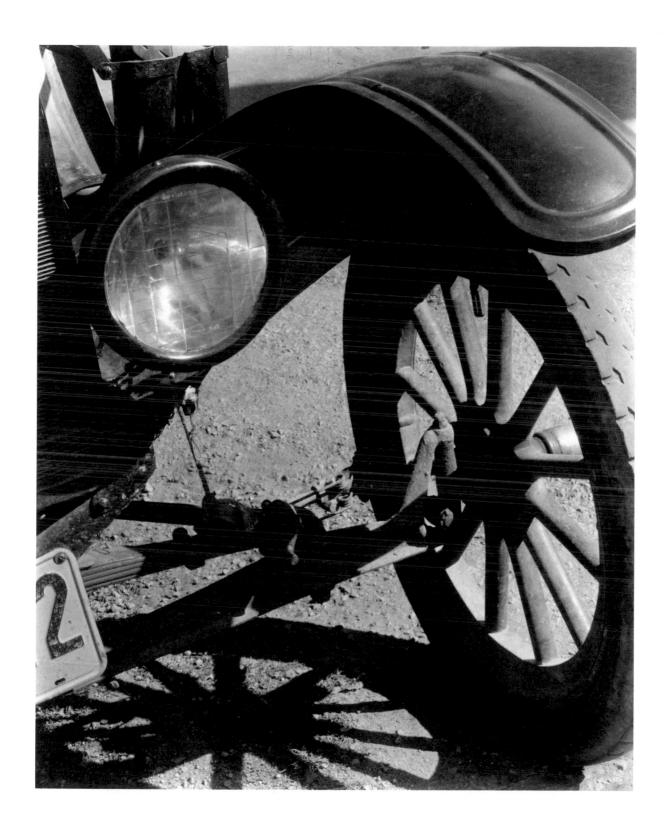

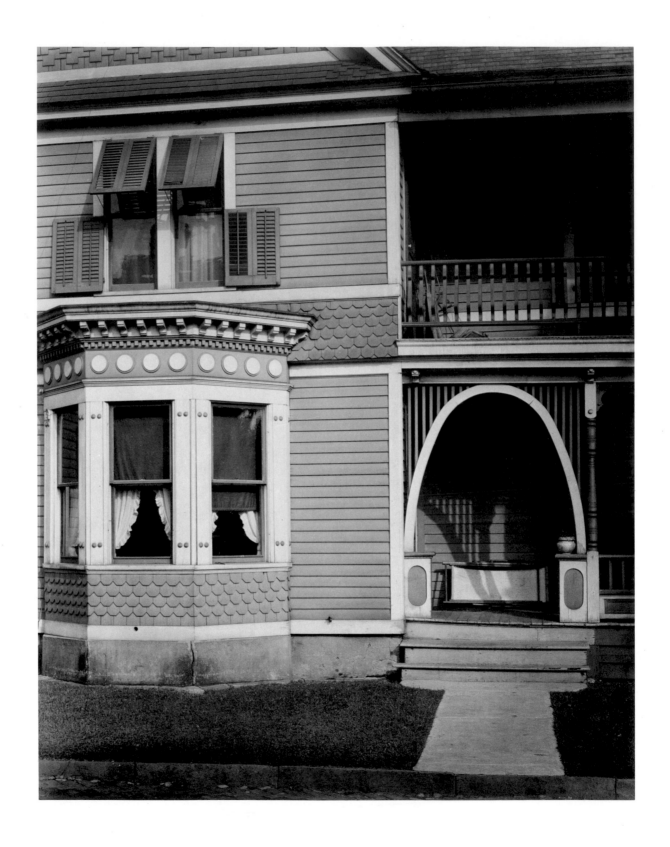

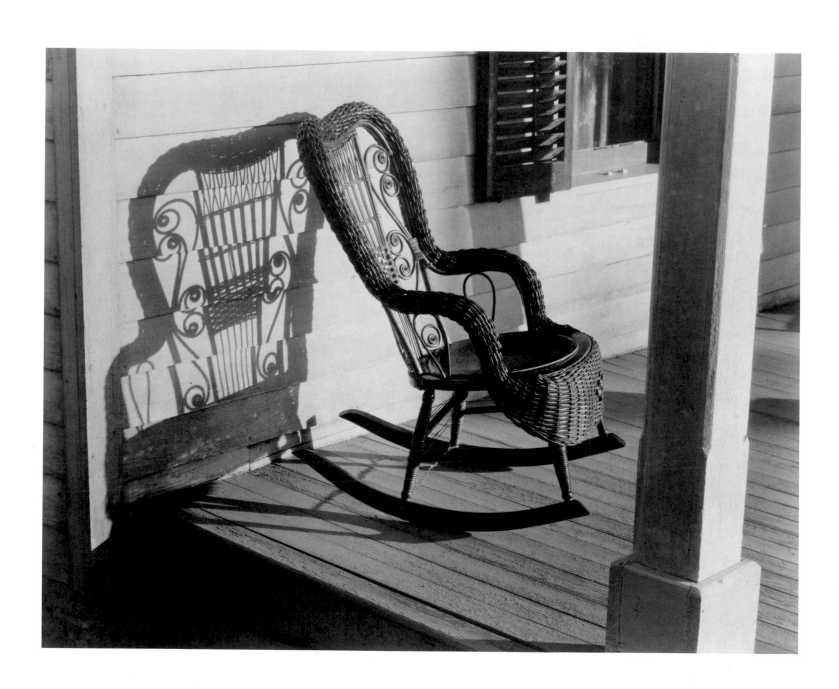

Earning a Living

Whistler, when asked: "With what do you mix your colors?" said: "With brains." My life as an advertising photographer was so coupled with tension and insecurity that as often as I could I mixed my work with humor.

The man on the donkey was president of a company making little boxes which buzzed when they sensed uranium ore. He was busy, but I persuaded him to leave his office to go with me out into the Mojave Desert, and there to sit on the back of a sway-back donkey with his uranium detector. The man on the lift truck was president of a materials moving company. I decided that it would be more amusing to photograph him on the smallest lift truck rather than on the largest. And to make it and him look smaller, I had the shipping room make an impossibly large box and paint it black to give a sense of great weight.

The first photograph (of ham and eggs) is what I did to avoid certification to a mental hospital when told to photograph a plate of ham and eggs. In God's name how does one photograph a plate of ham and eggs? My escape was to amuse myself.

The fourth photograph — the man peering into the complicated prism — was made in a plant where I was told on arrival that I might not photograph anything they were doing — it was top, top secret. I made this tomfoolery which said: "They do something scientific with glass." Years later I found out they were making the lens for the camera in the U-2, the spy plane.

The photograph of the potter shaping a vessel was made for Lenox China. It showed, I hoped, a man making love to what he makes.

I suppose I got swept away when I came upon the mountain of black and white floor-mop material in a New England factory. I asked the mop maker to leave his machine to sit in the midst of that mass of confusion.

The picture of Gypsy Rose Lee and the girls in her act was one in a series I made for Gypsy's publicity. She was a friend, bright as can be, a "gentleman" in all her dealings with me. Her shows were funny, kidding hot sex. This photograph tries to do the same.

It may look from this selection of photographs that earning my living with a camera was an ever-joyous romp. It was hardly that. Mostly it consisted of making unchallenging, dull, but profitable pictures, which ran in one issue of a magazine — then to be carted away by the garbage man within the month.

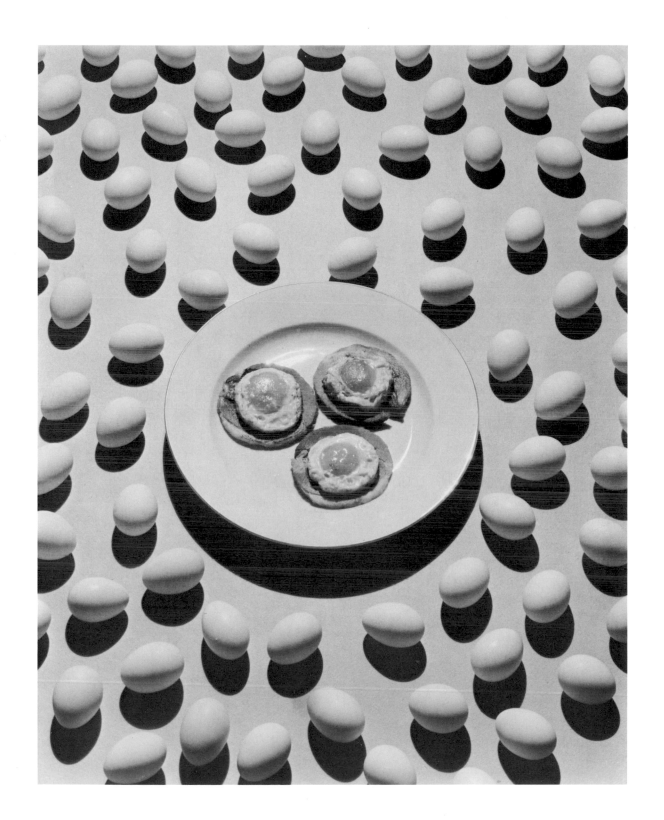

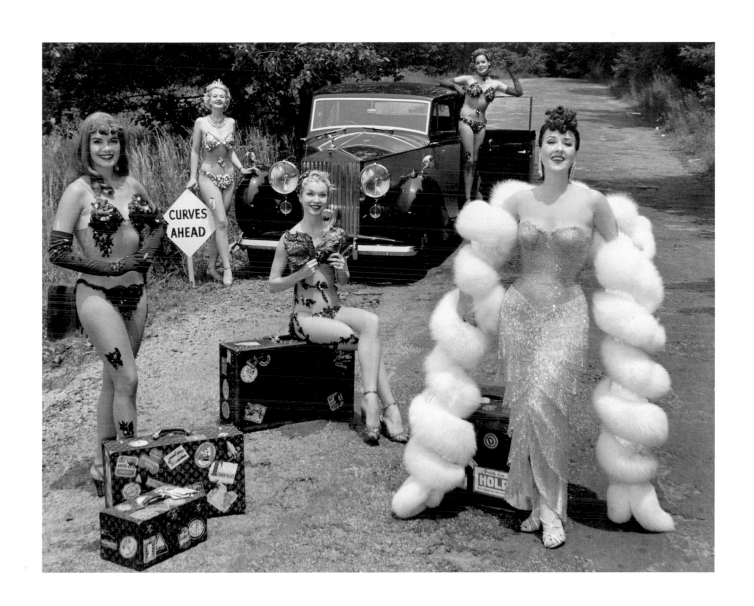

What Light Can Do

The medieval alchemist spent his days attempting to turn lead into gold. If only he had glanced out his window as the sun came from behind a cloud, what a turning of lead into gold he'd have seen — especially if the sun got behind things to shine through them. The sun doesn't have to shine on tropical foliage (pages 71–74) to make magic; it makes it in your own backyard if you are open to magic. As Thoreau put it: "Only that day dawns to which we are alive." The second picture in this sequence is an example. I showed this photograph to a woman who used the path through the grass several times a day almost every day in the year. I asked her where it was. Her answer: "It's beautiful, but where is it?"

That's the trouble; people will fly to Europe to look at the adoration which Rembrandt, Caravaggio, La Tour paid to light — they will stand in awe in the center of that great vaulted room of colored glass, the Sainte Chapelle, but at home, if martinis are waiting indoors, they will not slow down to look as the grass around the door turns incandescent in the setting sun. And there's a lot more sunset grass in our lives than Sainte Chapelles or paintings in museums.

Much of what I photograph with a still camera I use as material in my films. One film, entirely devoted to what light can do to ordinary stuff, is called *Hurrah for Light!*

There are occasions when, if you photograph what light does, you have to move fast. The sun and clouds never hold still, and when you see a miracle of light happening out front, you are certain that within seconds it will disappear. Even if the sun does come out again shortly, it will not look the same or as magical. Excitement is necessary to the photographer, and excitement never strikes twice. The first and last photographs in this sequence were exposed in a hysteria of haste: you frame the picture, you don't take time to think about exposure, you just give one of every kind of exposure your camera can produce.

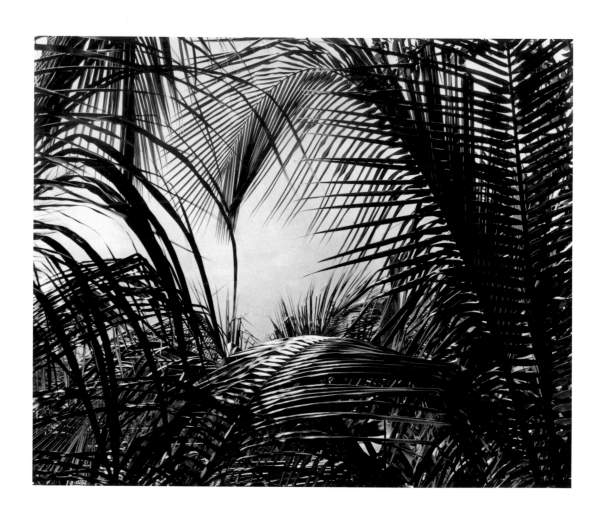

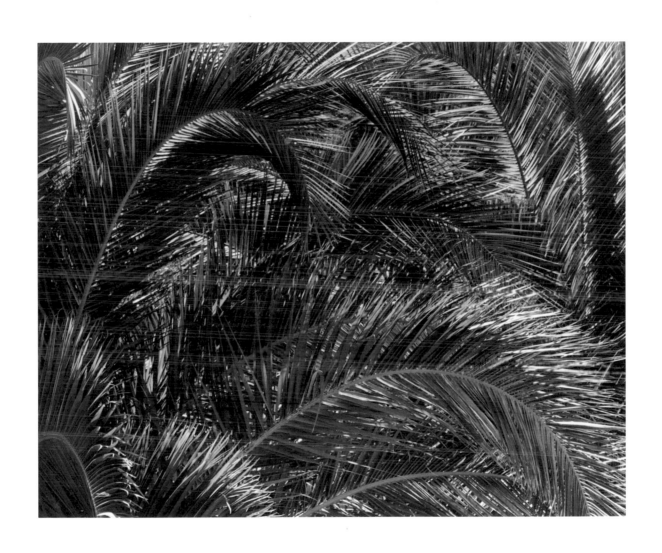

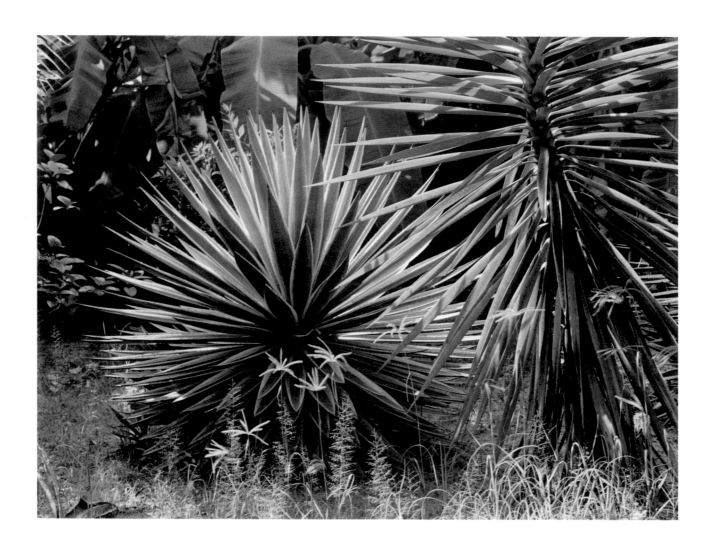

Trees

For approximately three years I specialized in trees — trees when their leaves were gone so they showed their skeletons. This concentration on trees was done both to pleasure myself and to try out an educational idea for student photographers, who have difficulty communicating in words to their teachers what they are trying to say visually in their prints. I see it as essential to the carrying out of creative assignments that the student "call his shot" (as in pool) before tripping the shutter, and then that he be able to tell his teacher what he tried to capture on film of concept and feeling. I saw as possibly helpful that students attach "feel-alikes" to each of my tree pictures as a learning process. These should be anything that came freely to mind on viewing each tree picture: titles, quotations, parallel images, equivalents, metaphors. My Webster gives as examples of metaphors: a ship *plows* the waves, a *volley* of oaths. This is the sort of thing I had in mind, so long as the "feel-alike" was not simply a physically descriptive "look-alike." I have found few photography students who are aware of their feelings for the things they photograph. More importantly, few know that what is asked of them is that they put their feelings into their work. Without knowing that this is their function, photographers can fall into the trap of photographing out of interest in aesthetics or technique for their own sake.

Below are some of the "look-alikes" which have been attached to these tree pictures by sensitive observers:

Tree on page 77: "An old priest, who, having heard confessions for fifty years, can no longer be shocked." Page 81: "The upness of youth," "Topless towers." Even the simple idea of "upness" and "topless" would be useful to a photographer when making a photograph since it would direct him to work for soaring height. Page 82: "Nightmare jungle," "War picture," "Let me out!" Page 83: "Nasty witch," "Gone berserk." Page 85: One viewer suggested "Winding road," which is a "see-alike" and has nothing to do with feeling. The person who said: "squizzle!" suggested far more the feeling he got from the zig-zag tree branches. Page 87: This tree has hardly any dignity, and so, "Being silly" from an eight-year-old is fine. "Foolish Easter bonnet" is not bad, but far better is what my wife wrote: "I certainly wouldn't trust the children with her."

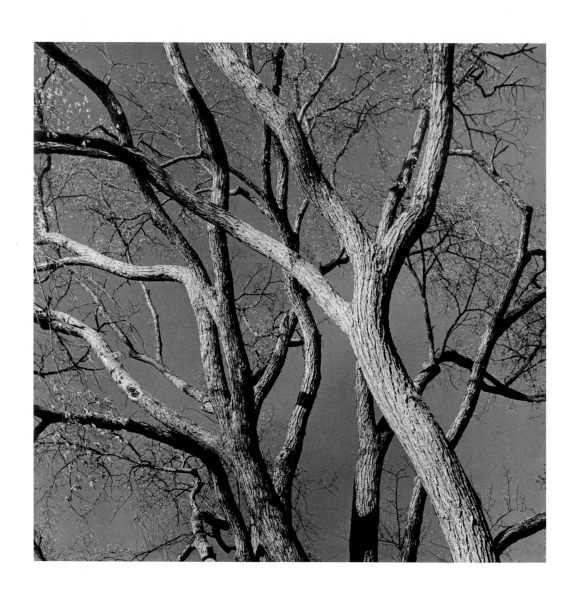

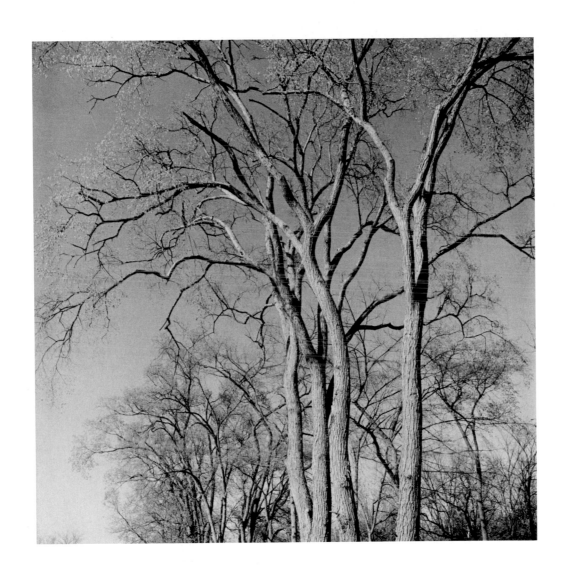

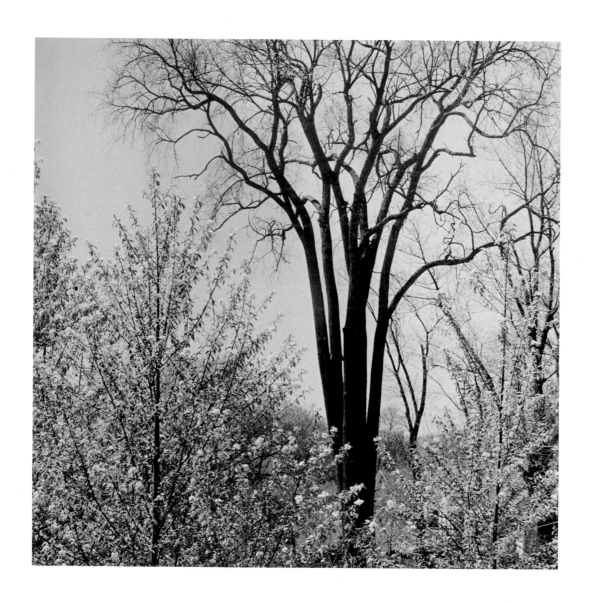

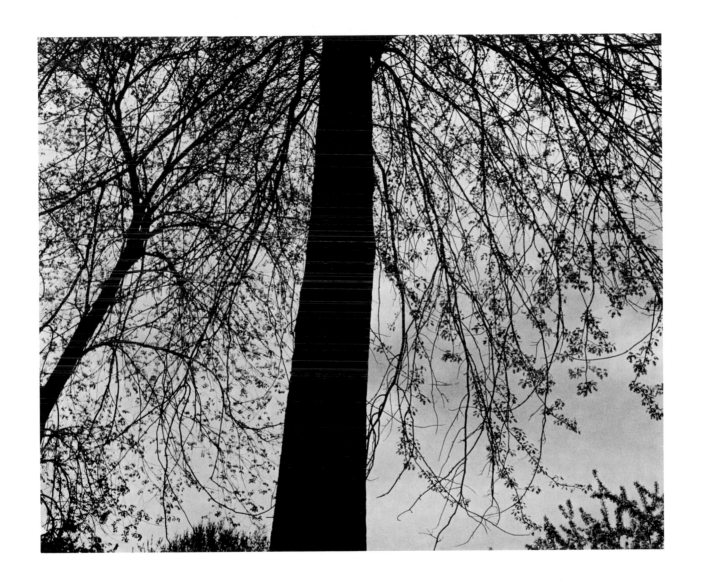

84

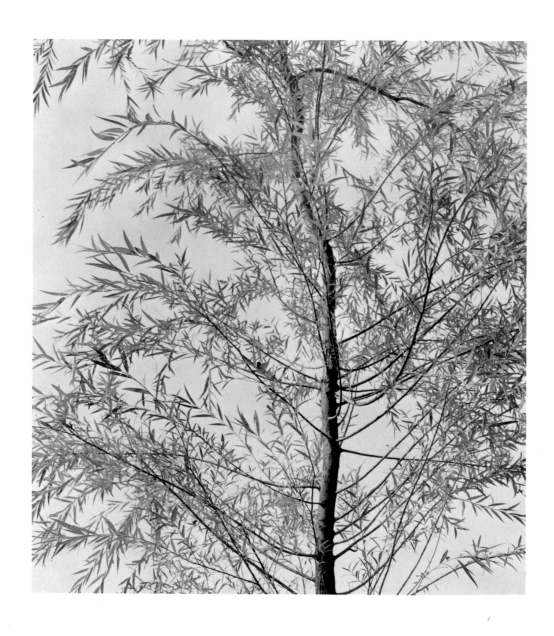

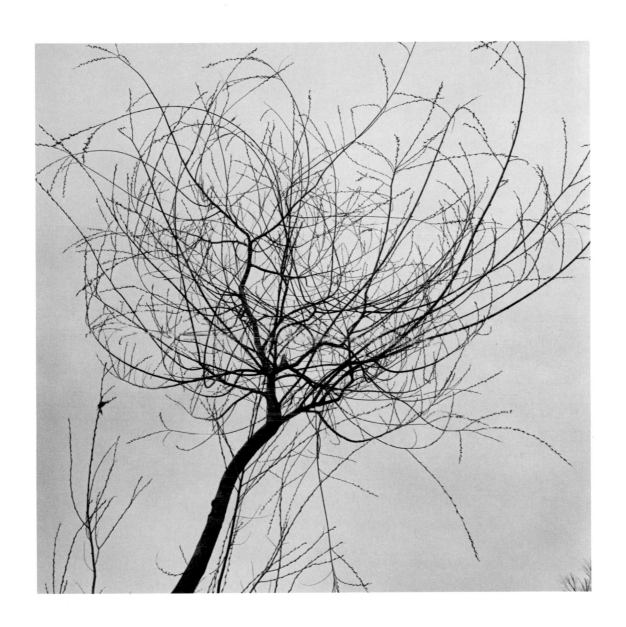

Summers on a Maine Island

"Our" Maine island is rocks, storms, cliffs, clouds, shipwrecks, and piled-up lobster traps. A photographer has to be mighty careful not to trip over the stereotypes; over the years so many nice painters and photographers have multi-Xeroxed them to the point where they have been cuted out of existence for my camera. I was heading into the woods on the way to photograph the last two pictures when a sweet old lady said to me: "Are you going out to photograph the beautiful things on our beautiful island?"

I suppose kindness should have kept me from answering as I did: "I am going out to photograph corruption and evil."

She protested: "Oh, dear, we don't have any of that on our island." I suppose such people never notice the sort of things pictured in the last two photographs of the sequence: the three dark, threatening sisters or the nasty, snarling, all-pointed-elbows bush — both out of Arthur Rackham illustrations in the books of my childhood.

There are no clouds finer than those that fly over Monhegan Island. I spent a large part of one long summer experimenting with cloud photography. I found the standard photographic process incapable of reproducing the subtleties of tone in the lightest parts of the clouds unless I increased print contrast abnormally. But this resulted in too much drama and even harshness. So all of these cloud photographs were produced by a messy and complicated method: very dark and overly soft prints were given an after-treatment in a special reducer, which acted selectively to heighten the brilliance of the light tones. The sixth cloud (a Pekingese) and the seventh (a llama startled by a loud noise) demonstrate how this process can produce all-over softness accompanied by brilliance in the light tones. Though the process is effective, it is not enjoyable since one makes fifty prints in order to end up with one that is satisfactory.

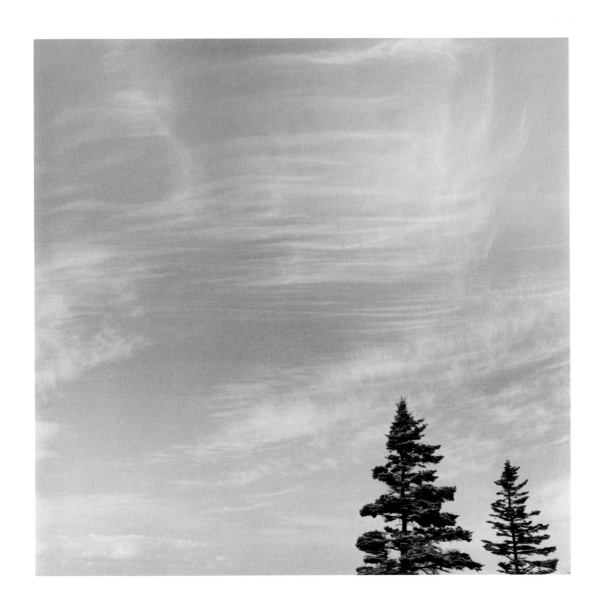

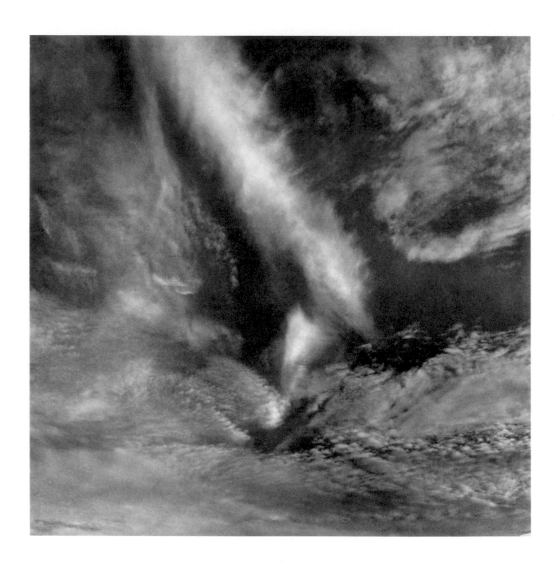

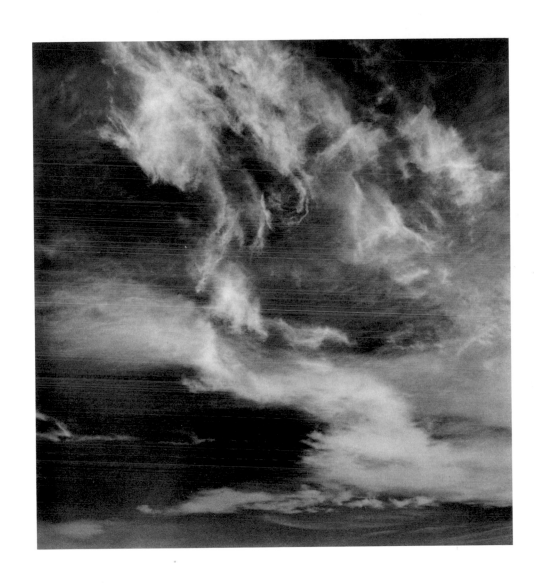

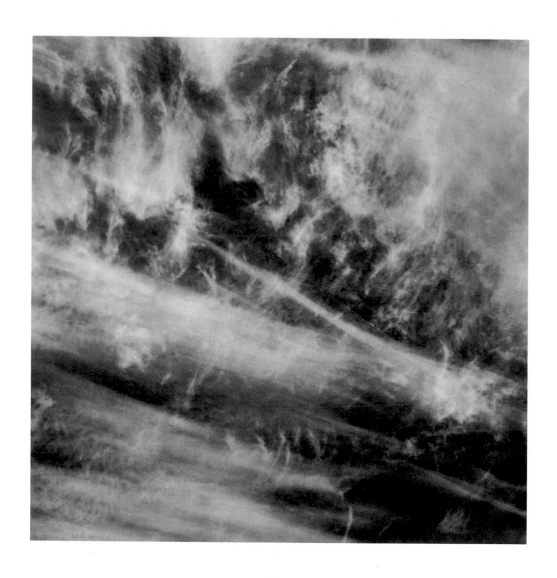

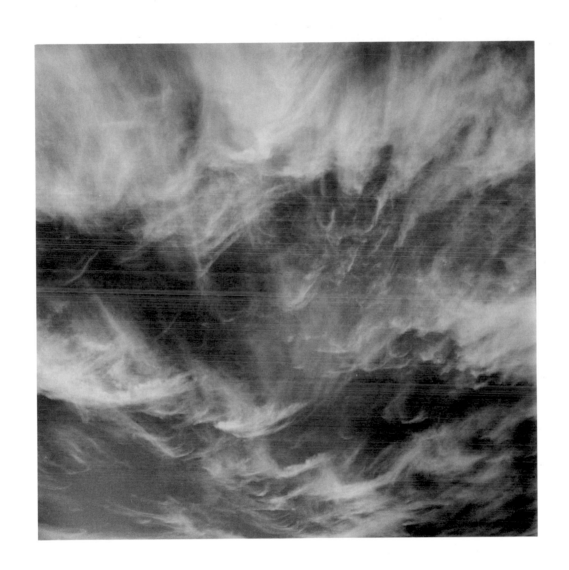

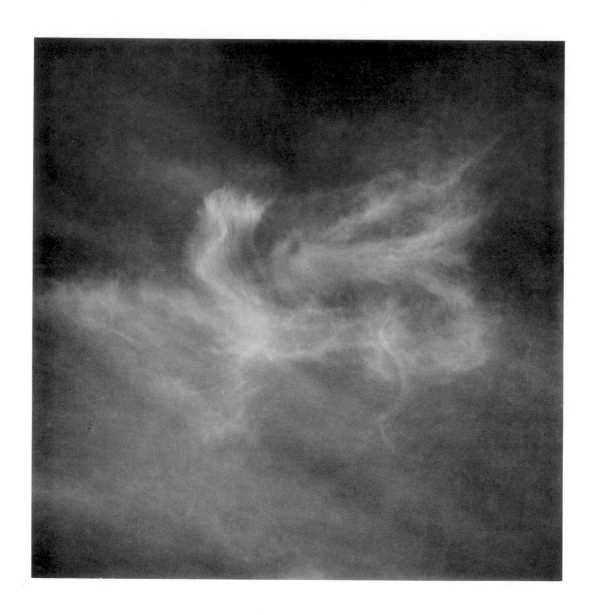

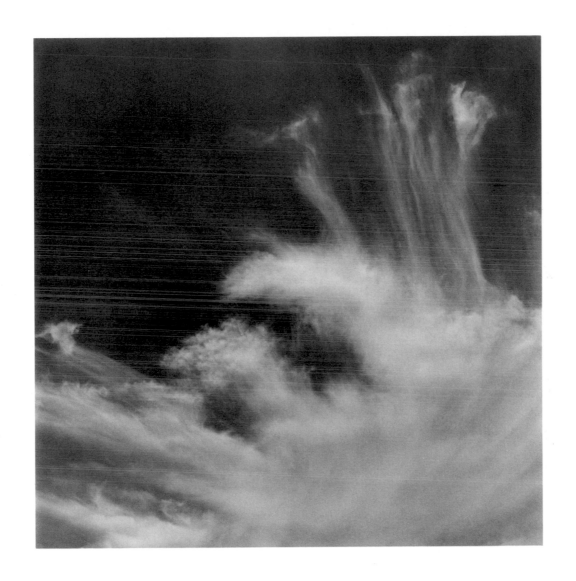

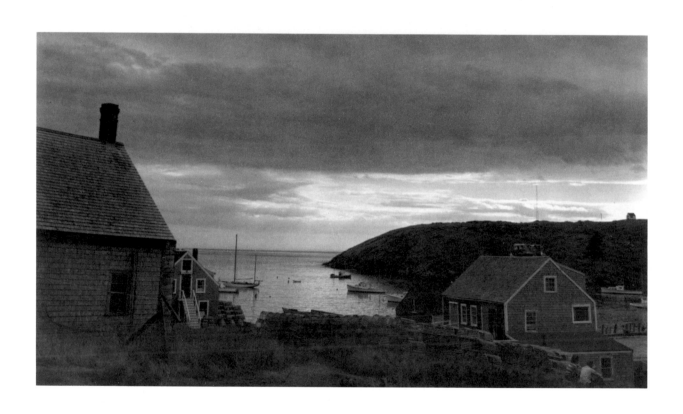

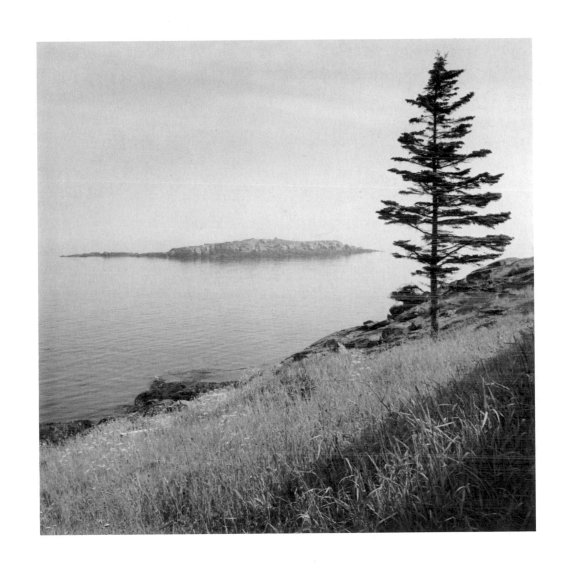

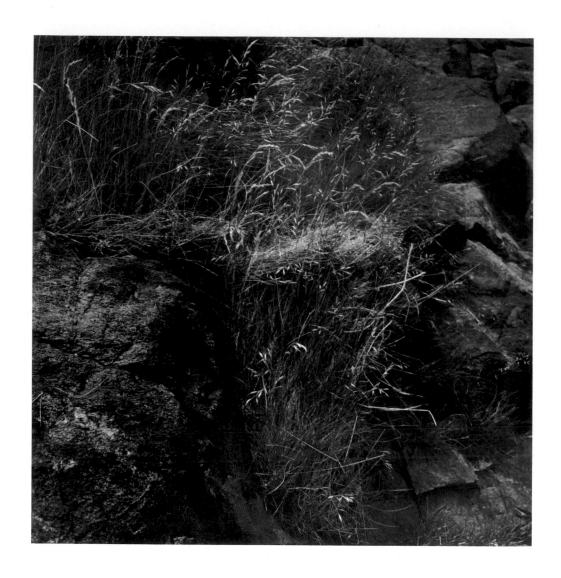

98

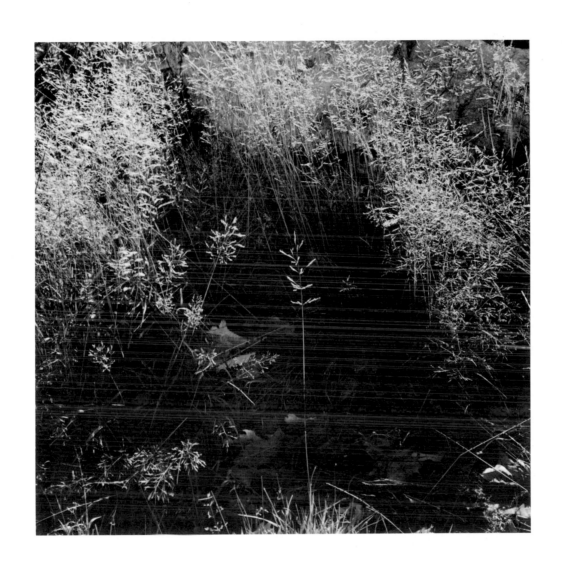

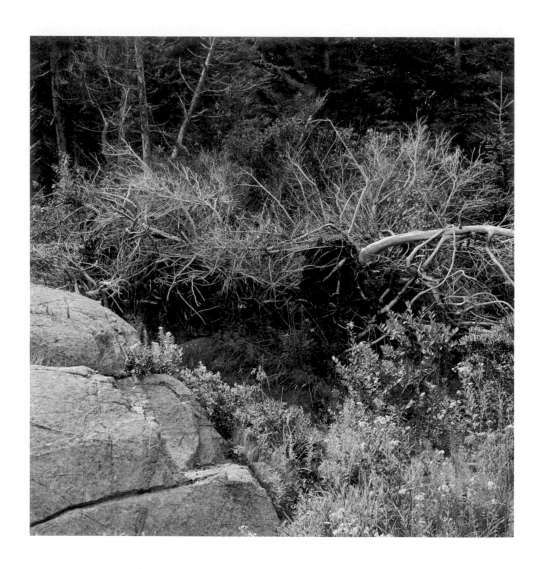

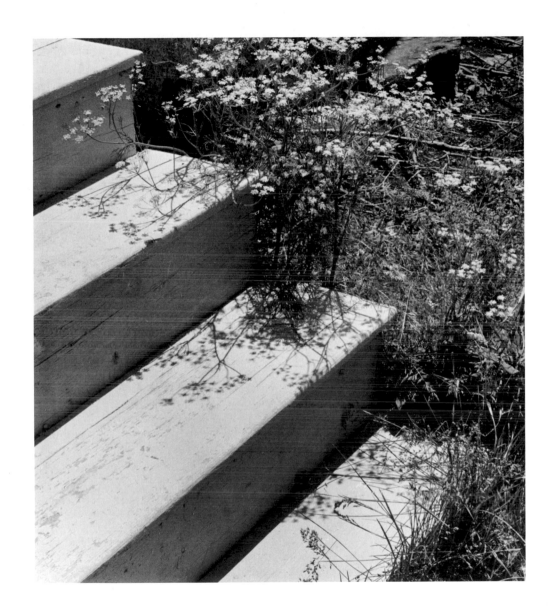

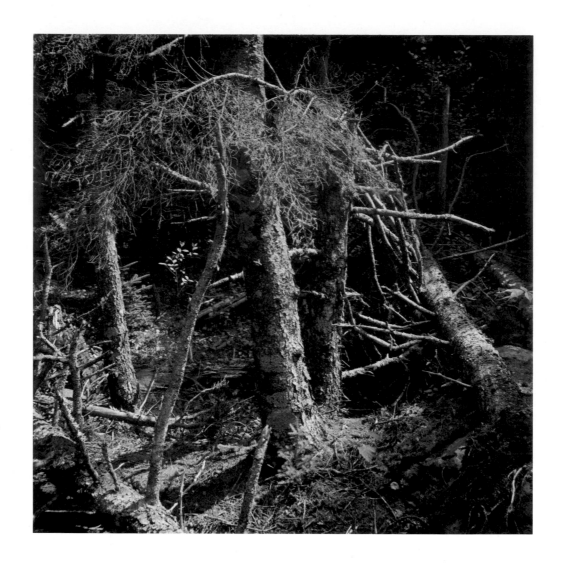

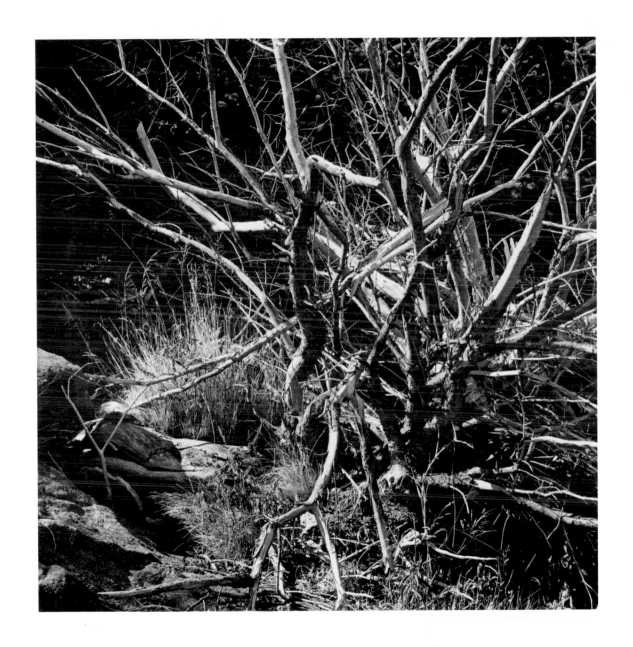

People Under Stress and People Doing All Right

As subjects there are some things which remain obstinately themselves regardless of who photographs them — mountains, perhaps, stay put more than most things. But a human being looks very different indeed when responding to different photographers. You get a bronze statue on a public square from Karsh, or an element in an interesting design from Newman, or a man bearing almost inhuman problems from Gene Smith, or people just living their lives without awareness of the camera from Cartier-Bresson. Then too, the conditions under which a person is photographed vary so widely. He will react one way when forced to sit for long minutes under five hot lights in a studio, and quite another way when going about his business without even knowing that the candid photographer has a hidden camera focused on him.

I have neither the skill not the courage to do candid photography, but I try my level best to photograph people so they are responding not to my camera but to a human situation. Sometimes I win and often I lose.

The first photograph in this sequence is of a man who laid claim to being just about the most aggressive salesman alive. I do not care for aggressive salesmen, so I asked him a question he didn't care for, and caught that surly, battering-ram look. The next photograph is of a former boss of mine. He was a doctor of psychology doing a stressful job of running a factory making pharmaceuticals — a job he never should have attempted. The third photograph shows a young man who looks as if he were about to burst into tears. He had inherited from his father the presidency of a corporation at perhaps too early an age. The next two are fooleries with S. J. Perelman, the humorist. Next is the painter William Walton, an enjoyer enjoying. Next is Whitfield Cook, who is in the act of collapsing over something I said. Then there is Dr. Louis Finkelstein, head of a rabbinical seminary, and William Lescaze, architect. The tenth page (four small pictures) is of Elisabeth Neilson. Smith College graduates will remember her as the reigning queen of Northampton — by occupation and by talent. Facing Mrs. Neilson is an after-rehearsal shot of Morris Carnovsky and Lee Strasberg, of the Group Theatre, conferring on an empty stage. The last two photographs are of Elia Kazan and Art Smith. They were made during the filming of an antiwar film, which I based on George Grosz's post–World War I drawings. Photographs on pages 108, 110, and 111 were made in cooperation with Mary Morris.

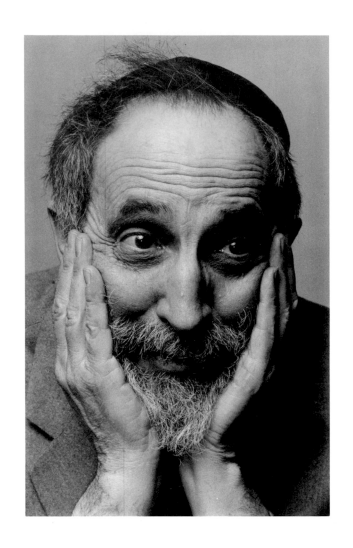

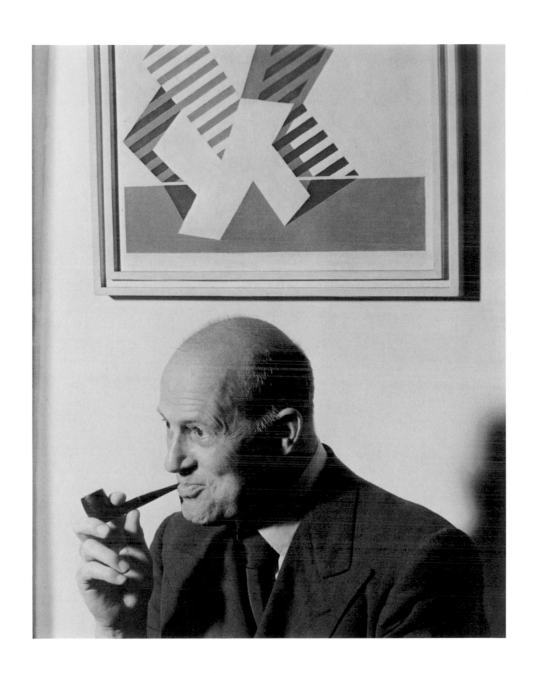

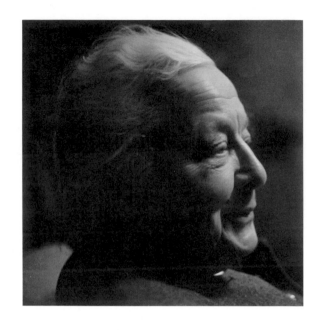 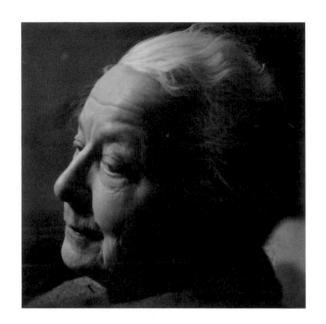

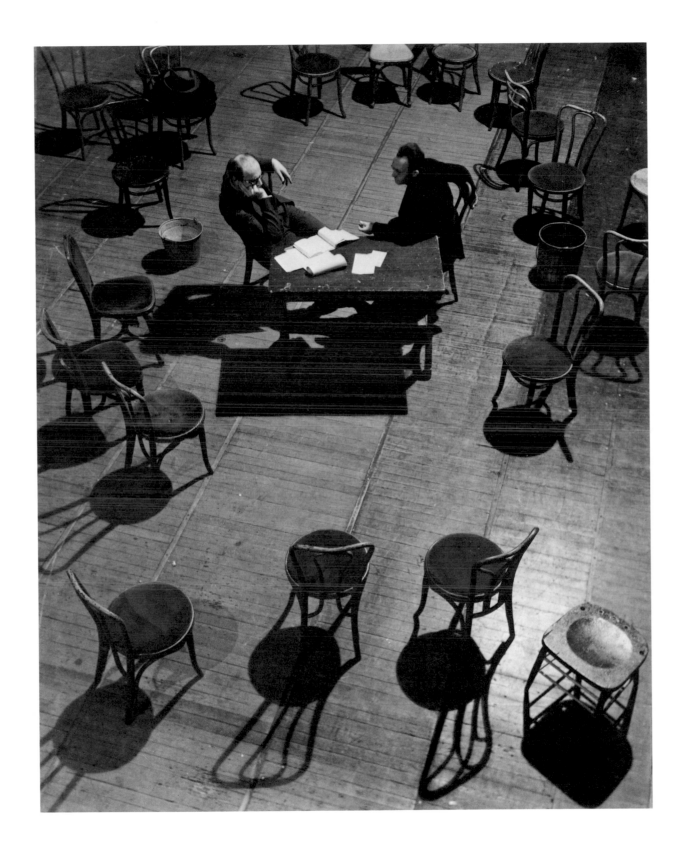

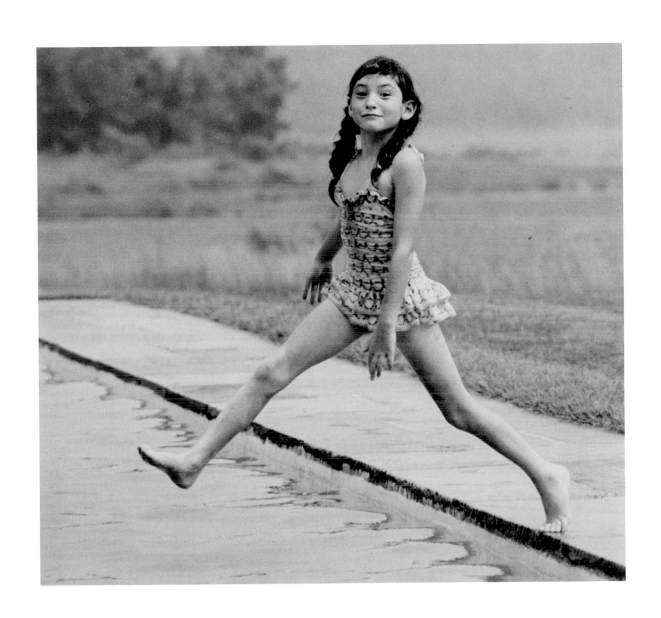

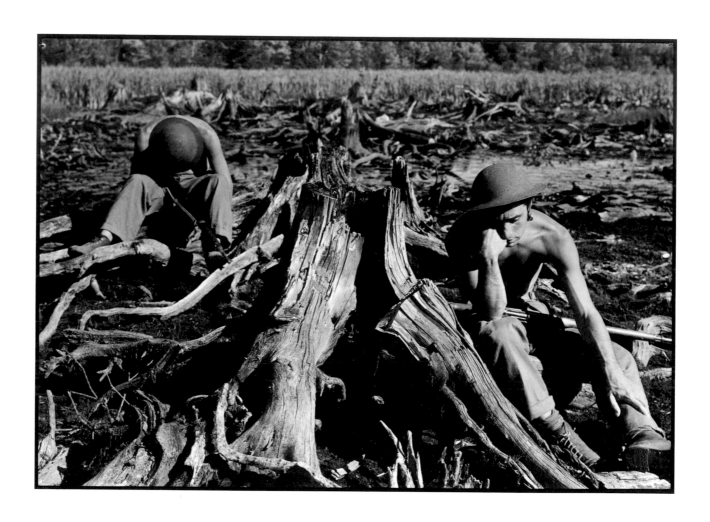

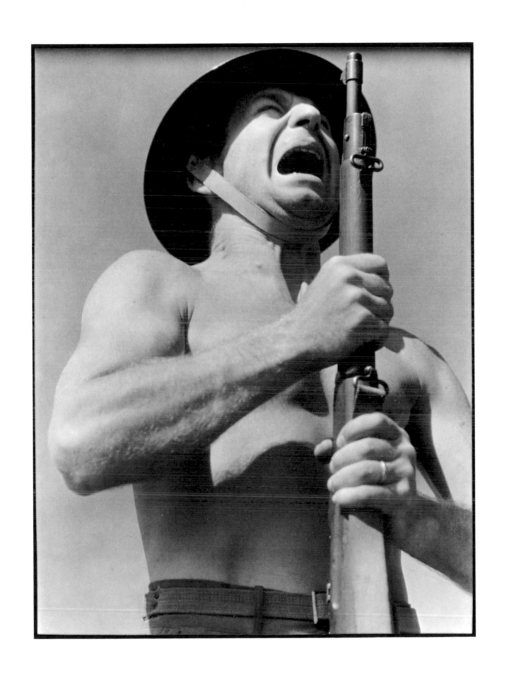

Late Work

This sampling of work done in the past fifteen years owes much to my quitting New York City to live in rural Vermont and to spending summers on an island off the coast of Maine. Four photographs (pages 122–125) were made just before the departure from the city, and they were all made within a block or two of our house. It may be that the inhumanity seen in the pictures of the same apartment house (pages 122–124) shows that it was needful that I leave the stone buildings for the trees.

I sometimes get parallel images in my head when I look at certain things, and the two oil lamps, waiting to have their chimneys cleaned, made me think of curvaceous Turkish belly dancers. It would be entertaining to film the two lamps reflected in undulating water to make them dance before an unseen pasha. I did make a film which relates closely to the last four photographs, *A Look at Laundry*. It shows sequences of washing on the line alternating with sequences of Greek sculpture and bas reliefs. At first the sheets plunge wildly in a high breeze, and this is juxtaposed to Greek horses rearing and dashing. Then a sequence of smoothly flowing, gently floating sheets is compared to the wavelike lines in the clothing of Greek women. At the end of the film, sheets moving slowly and majestically are related to noble, stately statues of Greek gods.

All my work in later years has been done on a 2¼-inch wide roll film; I have never felt at home with smaller negatives, which have to be looked at through a powerful magnifier. I don't seem to be able to convince myself that anything of value to me can emerge from so small a negative. It may also be that I fear both the low cost of a negative and the ease of snapping away without thinking, feeling, or valuing what is before my camera.

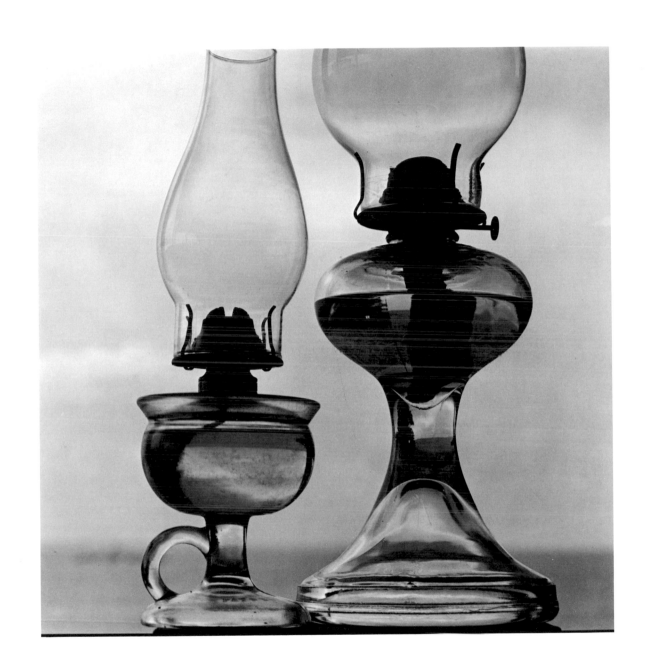

124

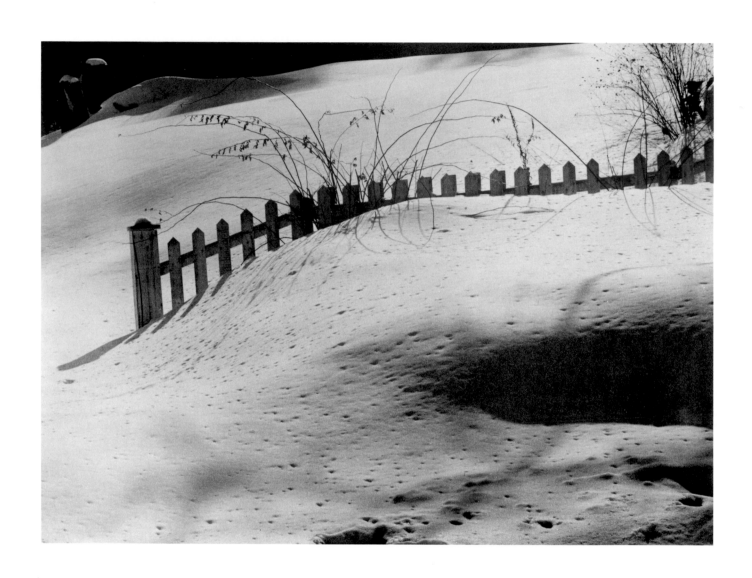

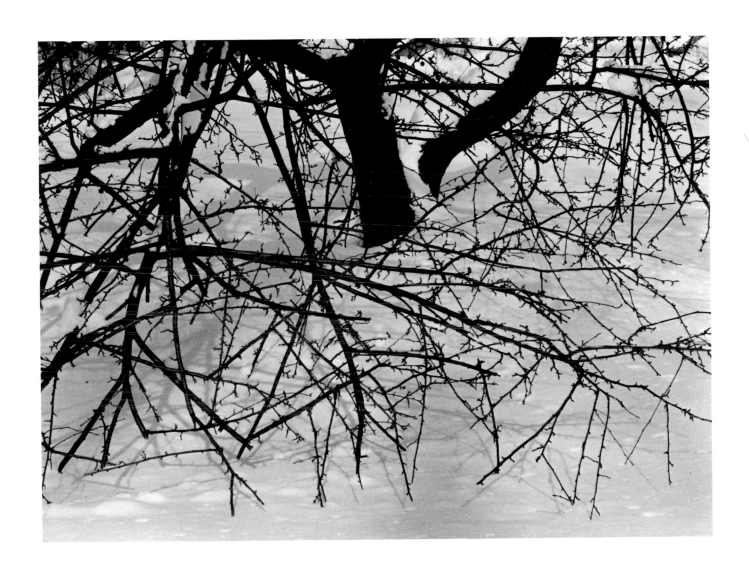

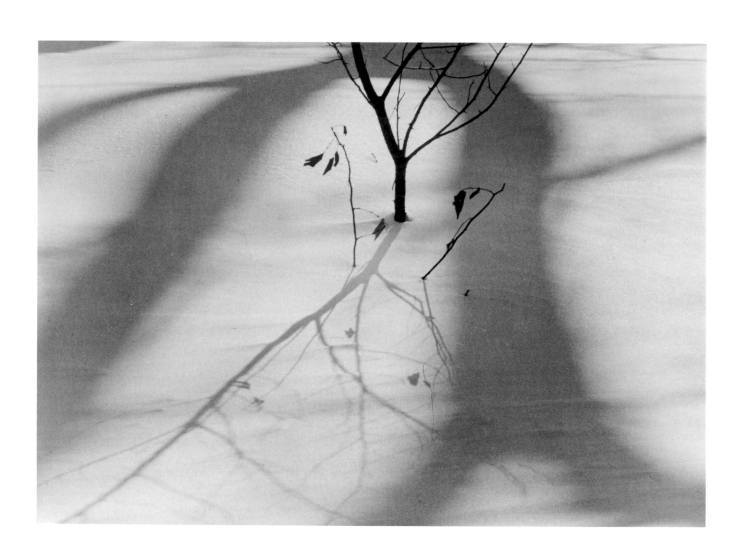

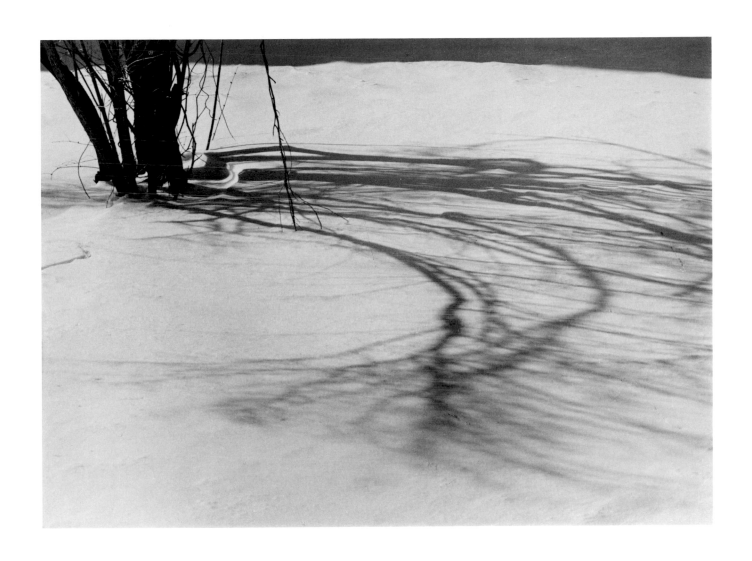

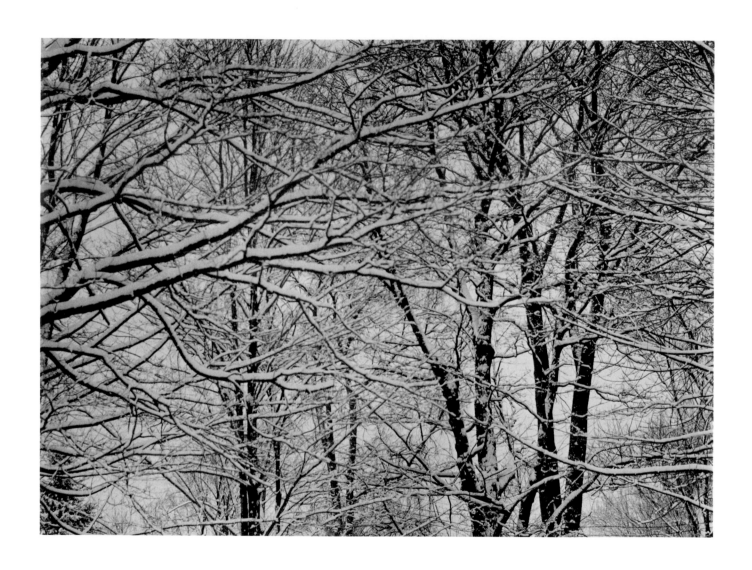

130

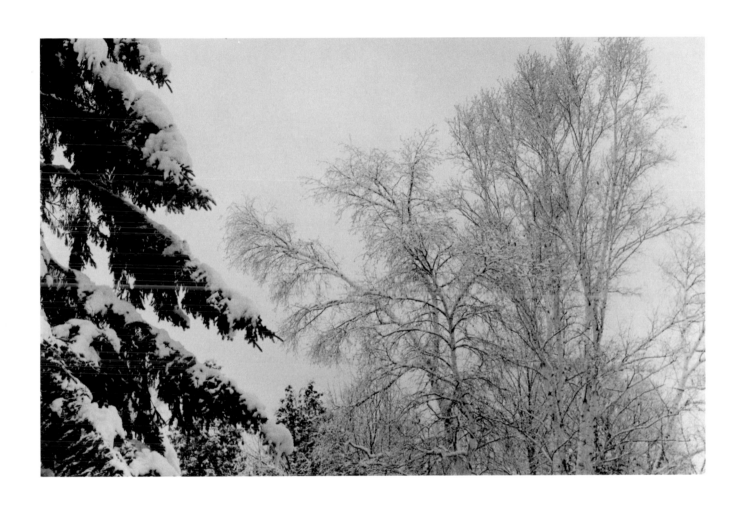

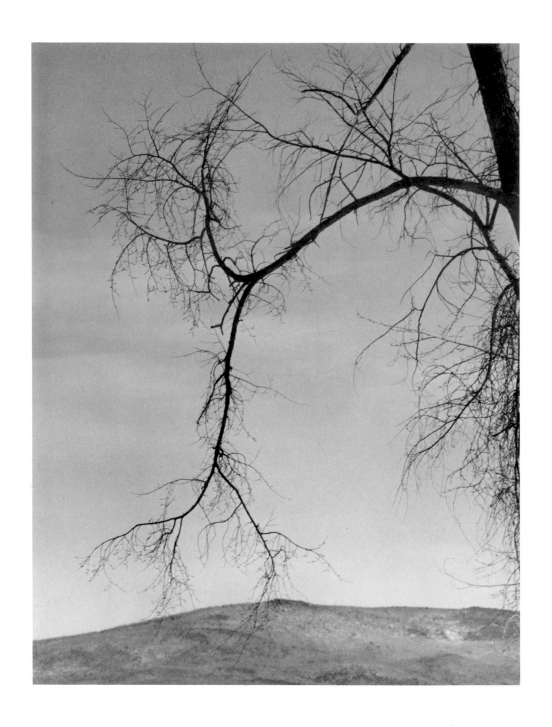

132

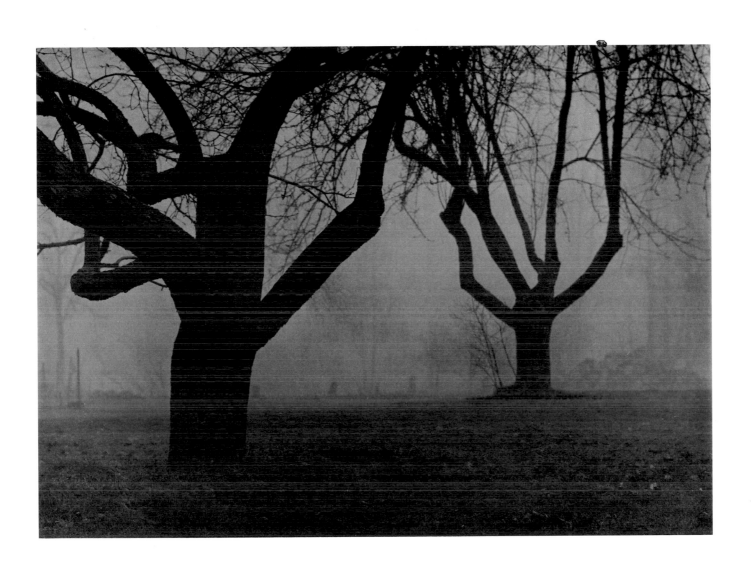

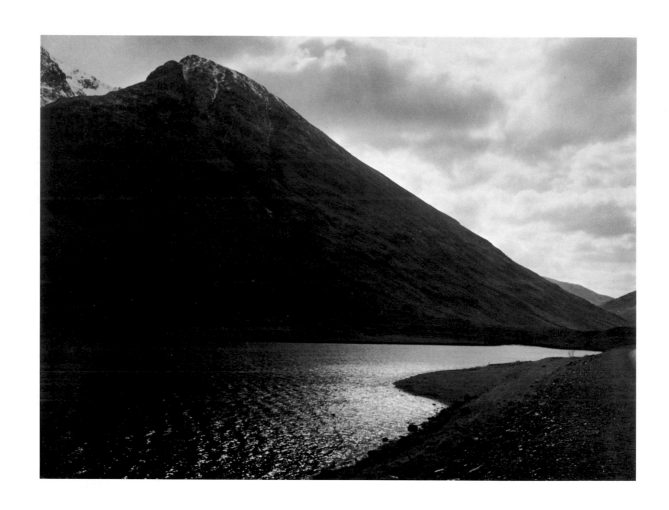

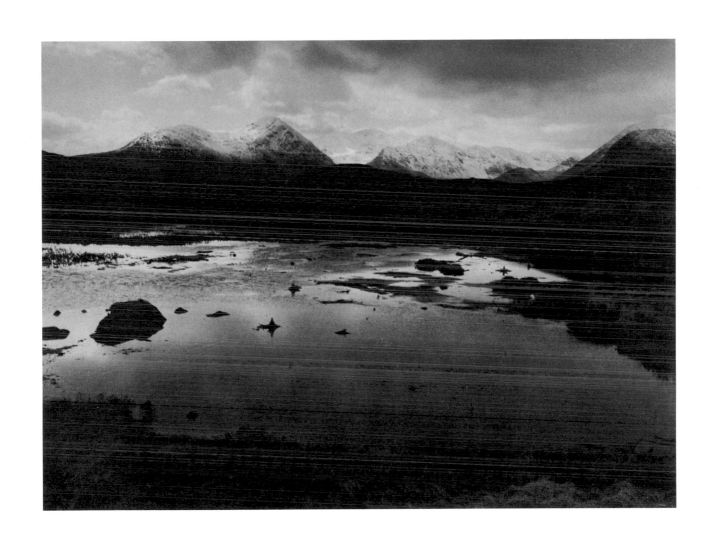

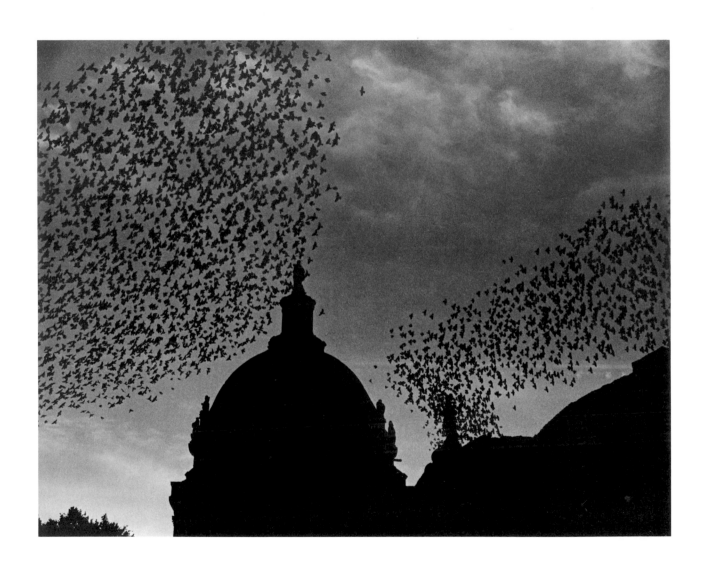

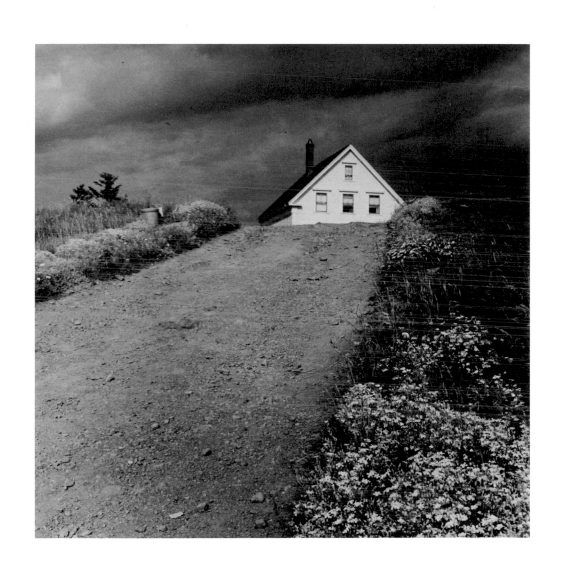

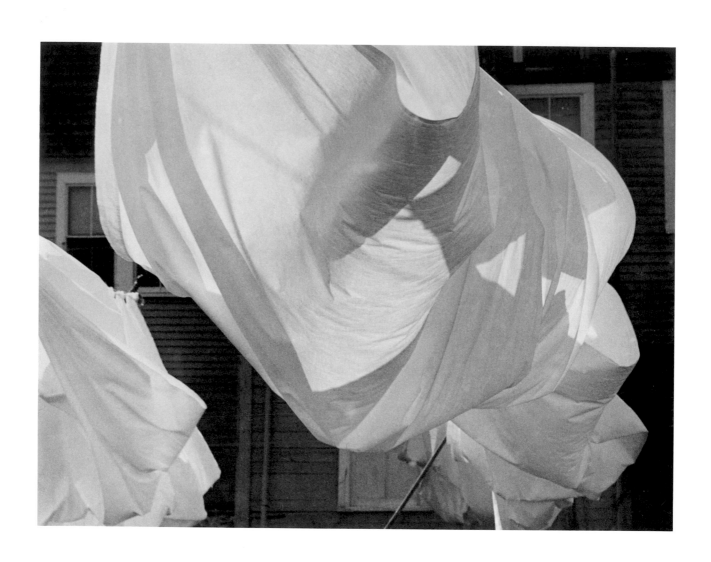

A Point of View: Technical Matters

From a technical point of view I see two acceptable approaches. I term the first "High Fidelity." It is represented by a print whose tones bear as truthful a relation to the brightness of the subject's tones as possible. Then there is the conscious departure from High Fidelity. This is the heightening of the tones at one end of the print's scale for the purpose of emphasis. Of course, there is such a thing as "Low Fidelity" or "Non Fidelity" produced by the innocent or mindless, but those are not to be sought after. The photographer in pursuit of excellence in technique and control must consider — even if he does not accept — the following observations. They apply equally to High Fidelity and departure from it for conscious creative purpose.

Contrary to most of what is written and gossiped, there is almost no "good" or "bad" in photographic technique. Such terms belong more in church than in the darkroom or in the field. It is far more useful to think in terms which relate to tonal emphasis — whether it is thrown toward the lighter or the darker end of the tonal scale, and, at the same time, subduing emphasis at the opposite end. One cannot have a gain in tonal emphasis at both ends; the laws governing photography tell us that if a print is to run from black to white, a separating of tones in one area of the scale must result in a crowding together of tones in another area. This means that emphasis must be accompanied by sacrifice. All creativity is the choice of one thing rather than another. One does not conduct Beethoven's Fifth Symphony with equal loudness from start to finish.

FILMS. There are no wonder films and no terrible films. There are differences in sensitivity, sharpness, graininess, and contrast capability. But practically all films of moderately high sensitivity (in the ASA 125–400 range) will do equally well for the brightness values of subjects. Only the very slow, finest grain, highest sharpness films fail in ability to register subjects of high or even normal brightness range.

FLARE. Everyone (except scientists) thinks of flare as the devil. This is nonsense; flare acts as a charitable angel for subjects of high contrast. It does reduce dark tone separation, but this can be used to enhance light tone separation. Many of this book's photographs resulted from the conscious addition of a measured amount of the equivalent of flare.

METERING EXPOSURE. A built-in or hand-held integrating meter is an averaging meter, and "works" only for average, nondiscriminating

photographers. To the discriminating its use would be equivalent to using a foot-wide whitewash brush for painting miniatures. Use a spot meter to measure the brightness of the darkest tone in which you wish detail plus a notebook for the first decade of the spot meter's use.

LATITUDE OF EXPOSURE. For the photographer in pursuit of excellence and tonal control, there is no latitude. Only the absolute minimum of exposure that will register what you wish in the darks will do. Anything above that diminishes light tone separation. F. F. Renwick over sixty years ago discovered this, but no one heard him — not even Hurter and Driffield.

DEVELOPERS AND DEVELOPING VARIATIONS. I have over many years tested both scientifically and practically the effect of almost every developer's effect on tonal separation. I can now say with confidence: except for one ridiculous and harmful developer, pyrocatechin, all developers do just about the same thing for the tones that will end up in the print. And other than pyrocatechin, there is no such thing as a compensating developer (except in the advertising copy). Nor is there any compensating or other benefit in two-bath, high-dilution, water-bath, or other fancy method. Perhaps in the early days of thick emulsions, surface-developers and depth-developers had effect, but today these merely distract from the act of photographing. And the idea that greater development compensates for less exposure is valid only for those who disregard years of proven experience. The cure for underexposure is a waste basket and the making of a resolution to take the craft of photography seriously.

STANDARD SILVER PRINTING PAPERS. All printing papers lie tonally. Only in the middle greys are papers truthful. They degrade dark tone separation considerably, but do far worse for light tones. And high-contrast papers lie far more than do soft papers. For example: thirty percent of the range from white to black of Brovira number two tells the truth — that is, separates tones as it should. But in its number six grade only twelve percent is truthful while almost ninety percent lies! If a print is to reproduce its subject with a reasonable degree of fidelity and the negative demands a high-contrast paper, the print will be a disaster. Some papers do a better job for the light end of the scale and some do better for the dark. In printing the photographs for this book I used those papers which best suited the tone values of each subject.

The following papers in grade two proved to do better for light tones and less well for the dark: Portriga Rapid, Ilfobrome, Kodabromide — with Velour Black, Medalist, and Polycontrast Rapid trailing a bit behind. The papers best emphasizing tonal differences in the darks (but at the expense of light tones) were Varilour and Brovira.

If a print's light tones are most important, reduce printing flare and fog; develop face down and only for recommended times. If dark tone separation is paramount, use a higher contrast paper and give it a bit of light fog. Long development does not make "richer" blacks; it can unrich them. There is no truth nor logic in the idea that a diffused source enlarger confers any tonal blessing that a condenser enlarger cannot. None!